Steina

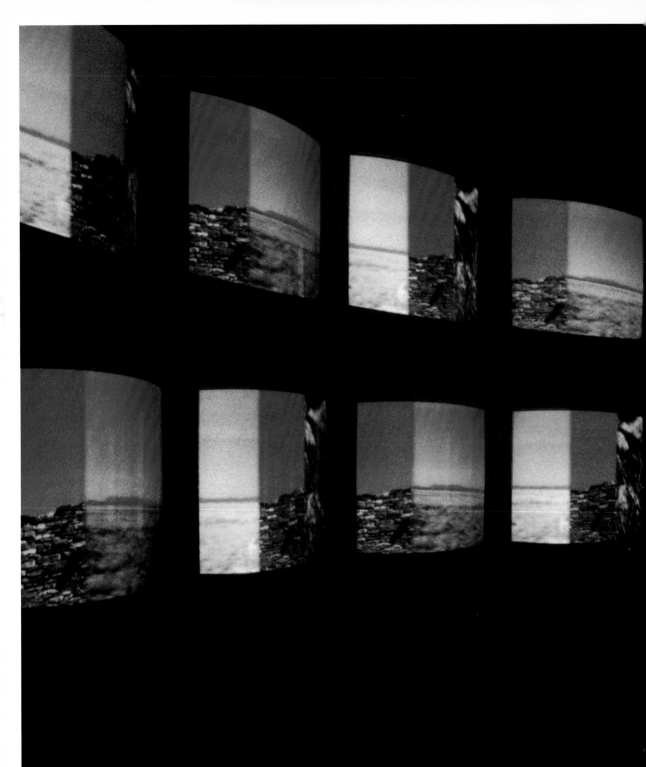

Steina

1970–2000

SITE SANTA FE

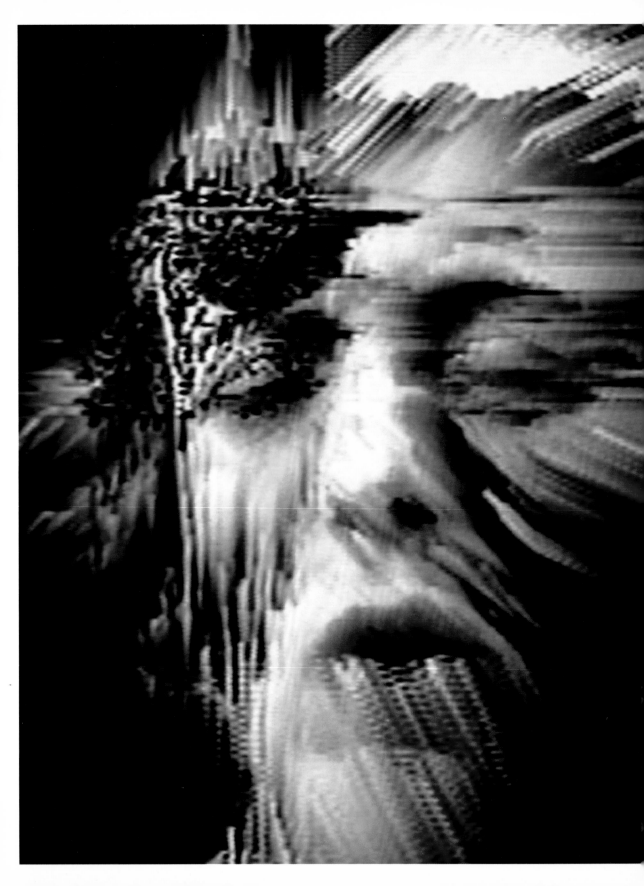

contents

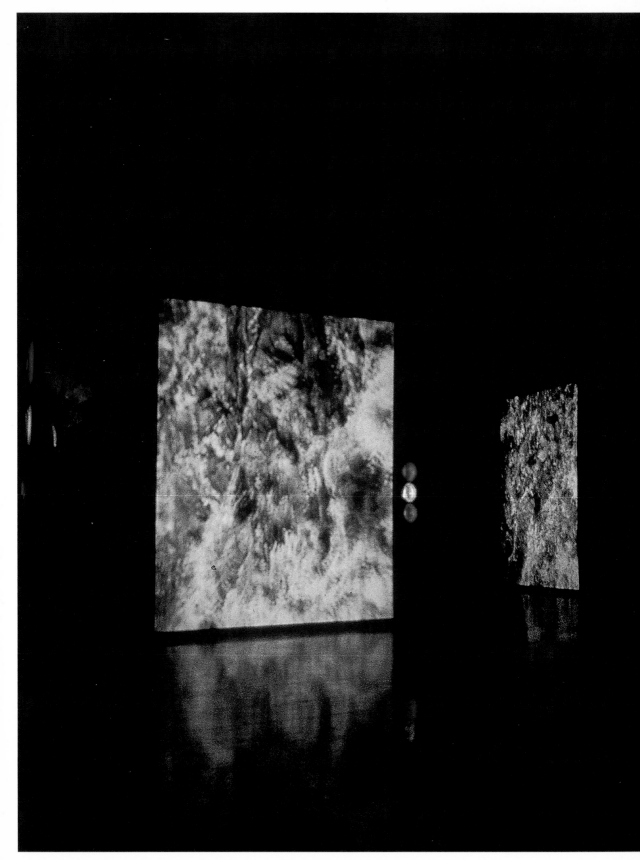

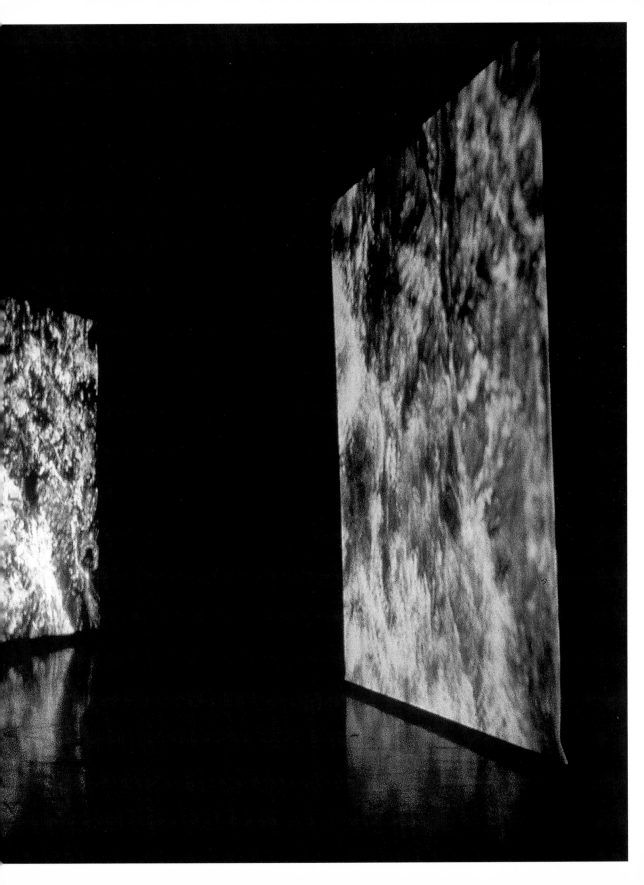

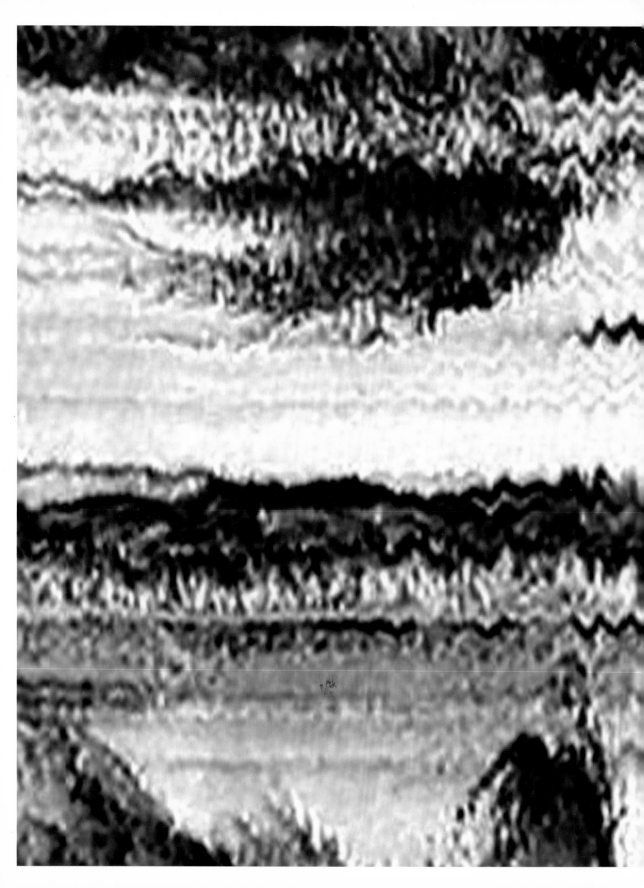

foreword

Laura Steward Heon
Phillips Director

SANTA FE IS A STRANGE TOWN FOR ART. In spite of the touristy desert sunset painting and bronze buffaloes for which it is generally known, it has long attracted some extremely sophisticated and difficult to classify artists, such as Richard Tuttle, Bruce Nauman, and the late Agnes Martin. Steina is one of these: an individualist who left the art world behind, with her husband and frequent collaborator Woody Vasulka, for the privacy of New Mexico in 1980. It is SITE Santa Fe's good fortune to have such an innovative artist as a neighbor, and to be able to make her work available to both Santa Fe and the larger art world.

Steina initiated an utterly singular trajectory through art, technology, and music. For more than thirty-five years, she has been a canonical fixture in the world of New Media art. By art historical standards, this genre is still in its infancy, and, like photography and film before it, it has had to justify its existence as an art form. Critics of New Media art embraced Steina's early technical experimentation and her ability to build machines, such as *Allvision* (1976), which is frequently cited for its spatial innovation. These same critics, however, have given scant attention to the subtle, personal, and sometimes comic content of her work, drawn from her intimate life and the natural world. The exhibition at SITE and this catalogue will offer a unified and comprehensive presentation of her practice, which is long overdue.

Steina came to visual art from experimental music and engineering, and the character of her video work has much in common with the musical experiments of composers like Brian Eno, who delved into the sonic artifacts of technology. She approaches each project as a

left: detail from *Mynd*

composer, organizing her work around the language of music: duration, interval, rhythm, and repetition. This is one of the qualities that has generated such a rewarding exhibition, in which the installations build on each other, interweaving different lines of inquiry into a symphonic whole.

Steina: 1970-2000 marks another set of firsts for SITE Santa Fe. It is the artist's first in-depth retrospective and the first exhibition at SITE devoted entirely to New Media art. I am grateful to Steina for her puckish and light-hearted approach to assembling this expansive exhibition. She and her husband Woody Vasulka have made the process a smooth and rewarding one. My co-curator Liza Statton has shown tireless dedication to sorting out the intricacies of Steina's work. Joanne Lefrak, Katia Zavistovski, Tyler Auwarter, David Benner, and SITE's preparator crew ably guided the exhibition through technical and other challenges. Additional thanks go to Brian Bixby for his technical assistance. Gene Youngblood, in his interview with Steina, and Steve Dietz, in his essay, expand our under-standing of Steina's work and its context. I am thankful, as always, to the Board of Directors of SITE Santa Fe, and to The Andy Warhol Foundation for the Visual Arts for their sustaining generosity.

Steina (Née Steinunn Briem Bjarnadottir)
b. 1940 in Reykjavik, Iceland
Lives and works in Santa Fe, New Mexico

Liza Statton
Thaw Curatorial Fellow

INITIALLY TRAINED DURING THE 1950S AND '60S as a classical violinist with a background in music theory in Iceland and Prague, Steina has, over the past three decades, created a remarkable body of work that deftly merges the disparate genres of music, art, and technology in innovative and provocative ways. Steina's vast oeuvre includes live performances, opto-mechanical kinetic sculptures, single-channel videos, and multi-channel installation "environments." Such a broad range bespeaks her insatiable curiosity, immense creative capacity, and a resistance to easy classification. Despite Steina's refusal to be defined within an art historical -ism, her work embodies the diversity, technological experimentation, spatial innovation, and interactivity that have become hallmarks of New Media art today.

Steina has said that "every artist's duty is to be disobedient." [1] Upon moving to New York's Lower East Side in 1965 with her husband, Woody Vasulka, she found herself surrounded by like-minded artists who similarly eschewed the exclusivity and conventionality held by the art world at the time. Known simply as the Vasulkas, Steina and Woody explored New York's cultural underground, videotaping live and impromptu performances as seen in *Participation* (1970-71), and were early proponents of multi-monitor installations such as *Matrix* (1970-72) — a work that revealed how, through the direct manipulation of video's electronic signal, new aesthetic possibilities could be realized.

Steina and Woody's collaborations often extended beyond their own work and into the community. In 1971, they, along with Andres Mannik, co-founded The Electronic Kitchen (known today as The Kitchen) — an experimental space dedicated to dance, music, per-

formance, and electronic media art. During this period, which was characterized by experimentation, technological change, and spirited collaboration, Steina began to explore the violin's capacity for producing visual imagery through sound – a concept which she eventually translated into her seminal work, *Violin Power* (1978). A performative self-portrait of the artist, *Violin Power* is also an assemblage of earlier films that presents Steina's study of the relationship between music and the electronic image. In the original version, Steina transforms her violin into an image-generating tool in which the sounds and vibrations of the instrument affect the image seen on the screen. Steina views *Violin Power* as an endlessly evolving project, and since 1978 she has publicly performed various iterations of the piece at different venues around the world.

In 1974, the Vasulkas moved to Buffalo where they met other avant-garde pioneers of media art through the Department of Media Study at SUNY Buffalo. During this period, Steina employed new types of image-processing equipment that could manipulate video in heretofore unprecedented ways. She also experimented with the camera and built machines such as *Allvision* that explored the phenomenology of optics and the mechanics of the video camera – two themes that underscore much of her work. In 1980, Steina and Woody relocated to Santa Fe, New Mexico, and landscapes soon become a leitmotif for Steina. They feature prominently in her multi-screen installations *The West* (1983), *Geomania* (1987), *Borealis* (1993), and more recently *Mynd* (2000).

During the past two decades, Steina has received numerous awards and grants from a variety of organizations including the Rockefeller Foundation and the National Endowment for the Arts (1982); and the American Film Institute which presented her, along with Woody Vasulka, the Maya Deren Award for Independent Film and Video Artists (1992). She received the Siemen's Media Art prize from ZKM | Center for Art and Media Karlsruhe (1995), and received an honorary doctorate from the San Francisco Art Institute (1998). From 2006-2007, Steina was an artist-in-residence at ZKM where she co-organized and participated in the exhibition *MindFrames: Media Study at Buffalo 1973-1990*.

[1] Steina Vasulka, "My Love Affair with Art: Video and Installation Work," *Leonardo* 28, no.1 (1995): 15-18.

steina: a machine in the garden

Steve Dietz
Artistic Director
2nd Biennial 01SJ
Global Festival of Art on the Edge

AN ENDURING MEME MANIFEST IN THE CLASSIC NOVELS of Nathaniel Hawthorne, Herman Melville, Mark Twain, F. Scott Fitzgerald, and countless others, is that of the incompatibility, if not tragedy, of civilization's degrading encroachment on nature, especially through new technologies such as the locomotive, the automobile, and now, arguably, computer-assisted telecommunications.[1] In popular media, the "Iron Horse" steams across the prairies bringing devastation, even if unintended, in its wake; according to Joni Mitchell, for love of cars, "They paved paradise and put up a parking lot";[2] and in the ultimate insult, on August 29, 1997, the machines gained sentience and began an actual war. Ironically, only the Terminator can come back from the future and allow us another chance to learn to live in harmony with our machines.

The artist known as Steina is no moralist. Nor is she, at heart, an educator. Yet in this exhibition of thirty-one works created since 1970 there is, perhaps, a lesson.

HOW I LEARNED TO LOVE THE MACHINE. AND NATURE.
For at least its first century, photography, the first lens-based medium, was convulsed with accusations of "machine vision." It was simply . . . mechanical. Automatic. Mimetic. Where was the art? By and large the answer, especially as transmitted by the assured didacticism of influential Museum of Modern Art curator John Szarkowski, was selection. Point of view. What he called "Detail," "The Frame," and "Vantage Point."[3] While film and video have largely

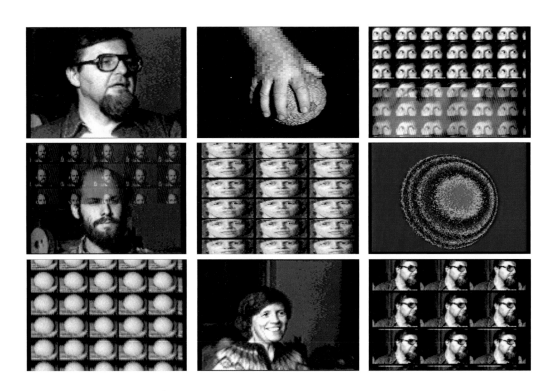

Stills from *Cantaloup*

avoided this debate through narrative, Steina, both in her own work and in her collabora-
tions with her husband Woody Vasulka, has explicitly avoided narrative in favor of an almost
puritanical enthusiasm for machine vision. For instance, in Michael Rush's *New Media in
Late 20th Century Art,* Steina is quoted as saying, "I was horrified by the idea that if you
hold the camera you control the image the viewer sees; so I put the camera on a tripod
and left the room. With the turntable the image would turn continuously, without a
cameraman. I wanted people to think of 'point of view'; that they are in a space controlled
by the machine." [4]

Steina may be referring to *Allvision,* one of her first "electro/opto/mechanical environ-
ments" described in greater detail on page 92. *Allvision* is the centerpiece of a series of
installation and single-channel works collectively known as *Machine Vision.* Steina talks
about these works, as the title *Allvision* implies, as going beyond the limitations of human
vision. Through 360-degree machine vision, one is able to get the full picture, so to speak.
What is most remarkable about the actual experience of these works, however, is precisely
how fragmented, episodic, and topsy-turvy the world is seen through the lenses of *Machine
Vision.* It's much more like a fun house than a crystal ball. "Some vision!" one might say. And
I think that is precisely the point. As Steina says in her interview with Gene Youngblood in
this volume, "I want people to forget space and time and just look. I want them to live for a
moment in a world where they've never been before."

She also goes on to admit, "Place has a far more central role in my work than I ever
thought," [5] and many people have commented on the apparent shift in Steina's work after
the Vasulkas moved to New Mexico in 1980. Works such as *The West, Borealis, Lava &
Moss* (1997), and *Mynd* each start with the landscape as input, and they are profoundly
affecting, but they would not be confused with, say, Ansel Adams's *Moonrise Over
Hernandez* (1941) or even Philip Glass's *Koyaanisqatsi* (1998). Each work fiddles with the
landscape as if an electronic signal; the landscape is presented on edge, off kilter as if via
a machine apparatus. The West may be Steina's paradise and Iceland her Eden, but they
are indelibly mediated by her camera machine in the garden.

THE STEINA MACHINE AND NEW NEW MEDIA

An important question clearly raised by this first in-depth retrospective exhibition is the relationship of Steina's machine vision to younger video artists and so-called New Media artists. Steina and/or Woody Vasulka are listed in nearly every video-based history in my library. They are listed in almost none that are primarily post-digital. She/they should be.

The New Media world that Steina grew up in and helped foment through her work and The Kitchen is the video art world. The new New Media world is primarily digital and computer-based. What is fascinating about Steina's work is how little difference these distinctions make except, perhaps, in where her work has primarily been shown up to now. In Lev Manovich's groundbreaking *The Language of New Media,* for example, he identifies Dziga Vertov's 1929 masterpiece *Man with a Movie Camera* as his "guide to the language of new media," and writes that "In [Vertov's] research on what he called the kino-eye interface, [he] systematically tried different ways to overcome what he thought were the limits of human vision." [6] Sound familiar? Steina has systematically explored the machine interface to vision her entire career, and the only difference that made a difference to her was whether it could be done in real time: "It's the most important thing . . . I would sacrifice any kind of image resolution, any kind of perfect image, rather than sacrifice real time." [7]

This becomes viscerally apparent in her hilarious 1980 video *Cantaloup,* about the Digital Image Articulator, which Woody helped build — wiring over 20,000 connections, as Steina's deadpan voiceover tells us while the video painstakingly shows the process — with Jeffrey Schier. On one level the video is a documentary about the "new" digital image, but from the perspective of the present the clarity of the descriptions— "The process in which we get this image of a sphere through a computer is called digitizing." "These squares are called picture elements or pixels."—is a bit like being talked to very slowly, as if you are deaf and need to speech read, even though you hear and understand perfectly well. The payoff is at the end of the video—and an 18-month invention process—when Woody is sitting in front of the camera as the image is being manipulated: "Oh my God. Let me do some senseless movement. Absolutely senseless." Then Jeffrey, who looks just like a geek who could invent

FIG. 1

Formula for Computer Art

an analog-digital image processor in 1978 should, gets in front of the camera. "Well, you probably want to see me move or even talk. You probably would like to see my eyes blink." And finally, there is the sound of a clap and Steina with almost childlike excitement saying "me, me, me" as she takes her turn. "I just need Woody out of the way there. Out of the way. Give me a close up of my eyes. [Laugh.] Okay, next person."

It's a funny sequence but also profoundly moving, as you can literally see in their eyes that their goofy antics belie the self-realization they're looking at something epochal. You had to be there. And Steina was. In 1978. Helping conceptualize the invention of an analog computing device for real time manipulation of the moving image at the pixel level. That's a *Make* magazine cover story more than 25 years before *Make* was first published. How's that for street cred?

IN 'N' OUT ART

In artist Jim Campbell's deceptively simple but productive diagram "Formula for Computer Art," **[FIG. 1]** he makes clear that virtually any input can become, through the black box of the computer, virtually any output. Steina and Woody understood this very early on, focusing on audio as an input controller for video output, even though this wasn't a digital process at the time. Again, whether it was New Media or new New Media is not a difference that made a difference to Steina.

In her seminal *Violin Power,* for example, both a video and a live performance since 1978, Steina "progresses" from a classical violinist to an experimental musician to a VJ using her violin as a MIDI controller to access different video clips on a laser disc. In 1992, Steina even performed *Violin Power* telematically between Santa Fe and Kit Galloway and Sherrie Rabinowitz's Santa Monica Electronic Café. [8]

Violin Power can be characterized as a dynamic "reading" of a database – the video clips randomly accessed on the videodisc – and is precisely what Manovich discusses in relation to the database as a "new symbolic form" and artistic practice in the 21st century. [9]

Steina's performance reaches out to connect with the "live cinema" and VJ practice of younger artists today from Toni Dove to DJ Spooky.

VIRTUALLY VR

To my eye, Steina's 1975 *Land of Timoteus* has the look of one of those bleak videogame landscapes, which I watch my son play on/in. In part, of course, this is due to its defamiliar-ization of the landscape through manipulation of the electronic signal. It is also, however, a precursor to Steina's installations, such as *The West* and *Mynd*, which use some of the same video processing techniques but at life size or larger scale and across multiple channels so that they become literally immersive environments. These environmental video installations are commonly produced by a new generation of artists, including Jennifer Steinkamp, Diana Thater, Pipilotti Rist, and Douglas Gordon. When Steina presented the projection-based *Borealis* in 1993, however, it was a relatively new approach. Perhaps that is why, as Steina relates to Youngblood, some viewers were physically affected by the installation and became queasy in a way not uncommon for full virtual reality environments. [10]

ON INFLUENCE

What Steina has accomplished over the past three decades is made abundantly clear in this exhibition. That she was a pioneer in exploring machine vision in relation to video is uni-versally acknowledged. That her work spanned what Lynn Hershman Leeson, a video and New Media pioneer in her own right, sometimes refers to as BC and AD—before computing and after digital—is an important fact for us all to understand as we approach the age of "art after New Media." [11] Exactly which artists Steina influenced in which ways is as hard to define as it is for Steina to list her own influences, and perhaps it is best to leave the last word to Steina on this topic.

"Our discovery was a discovery because we discovered it. We didn't know all those people had discovered it before us. It was just like feedback: pointing the camera at the TV set and seeing feedback was an invention that was invented over and over again. As late as 1972, people were inventing feedback, thinking they had just caught the fire of the gods." [12]

NOTES

[1] Leo Marx, *The Machine in the Garden: Technology and the Pastoral Ideal in America,* Oxford: Oxford
University Press, 1964.

[2] Joni Mitchell, "Big Yellow Taxi," on *Ladies of the Canyon,* 1970.

[3] John Szarkowski, *The Photographer's Eye,* New York: The Museum of Modern Art, 1966, pp. 8-10.

[4] Michael Rush, *New Media in Late 20th Century Art,* New York: Thames & Hudson, 1999, pp. 139-140.

[5] Steina interview with Gene Youngblood, *Orbits of Fortune,* p. 43.

[6] Lev Manovich, *The Language of New Media,* Cambridge: The MIT Press, 2001, xiv.

[7] Maureen Turim and Scott Nygren, "Reading the Tools, Writing the Image," *Steina and Woody Vasulka,*
Machine Media, San Francisco: San Francisco Museum of Modern Art, 1996, p. 53.

[8] Youngblood, pp. 40–41.

[9] Manovich, p. 219.

[10] Youngblood, p. 44.

[11] Steve Dietz, "Art After New Media," ISEA Symposium, Helsinki, August 19, 2004.
http://www.yproductions.com/writing/archives/art_after_new_media.html.
Accessed November 22, 2007.

[12] Lucinda Furlong, "Notes Towards History of Image-Processed Video: Steina and Woody Vasulka,"
Afterimage December 1983. http://www.vasulka.org/Kitchen/essays_furlong/K_Furlong.html.
Accessed November 22, 2007.

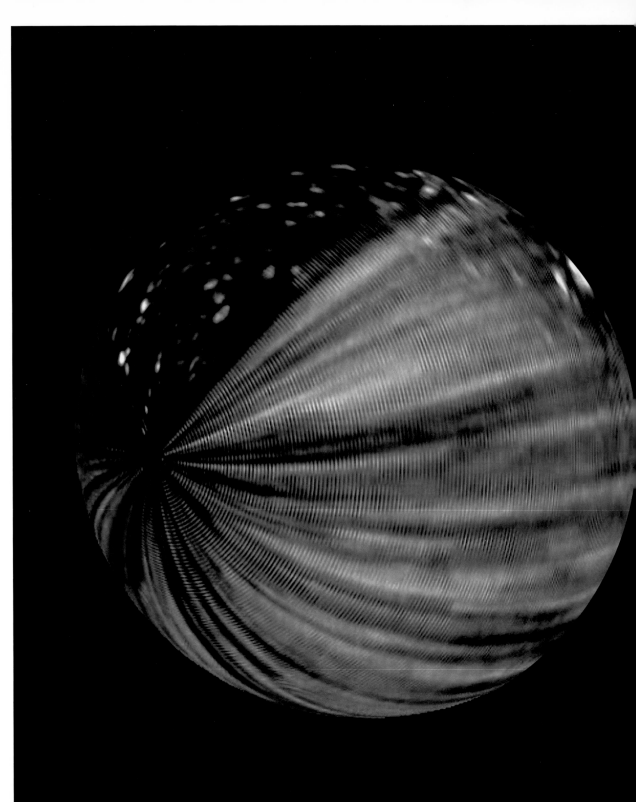

orbits of fortune

Steina in Conversation with Gene Youngblood

SANTA FE, NEW MEXICO, OCTOBER 2007

GENE YOUNGBLOOD __ Steina, I'd like to begin in Prague in 1965. You went there from Iceland in 1959 to study violin. Woody was a student at the Prague film school called FAMU. You met in 1962 and you married in 1964, in a ceremony under the ancient astrolabe in Old Town Square. In 1965 you came to the United States, to New York, for the first time. That was the year Sony introduced the first portable video equipment, called the Portapak, and the rest is history. You were a major force in shaping that history, but you didn't begin until the end of 1969. What were you doing in the five years before that?

STEINA __ I was a freelance musician, which was totally miserable. I loved playing my violin, but when I was faced with the prospect of being a professional musician, I realized I had made a dreadful mistake. I went from gig to gig wondering if there wasn't more to life than a black dress and meager fees. I refused to join the union. Twice I went to the union, and they handed me an application in which there was the question, "Are you now, or have you ever been, a member of the Communist Party?" I ripped the paper and walked out. I did this twice. So because I wasn't in the union I was paid $30 per session and they were paid $50. I had just enough money to wrap a long black skirt over my blue jeans and make my way to the podium. I got work by word of mouth. There was a huge freelance underground scene and we'd call each other when there were gigs. So I never had to look for a job. In fact, I've never looked for a job in my life. That's kind of being a princess, isn't it?

left: still from *Pyrospheres*

GY __ I would say so. Were these mostly classical sessions?

S __ Classical and musical theater. Later I found a program from Gilbert and Sullivan, and I saw in the program that I was sitting in the violin section and Charlotte Moorman was sitting in the cellos. I sent it to her and we both thought it was an interesting coincidence. She was doing the same thing as me, just hustling.

GY __ Was it your intention all along to come to America after Prague?

S __ No, not particularly. We came because my wealthy uncle gave me his social security benefits to live here for a few years. So we had those checks coming in every month. We had to augment it, but it helped a lot. I came in January and Woody came in May. I spoke some English, but when Woody came I suddenly had this deaf and dumb guy on my hands. I had to sit next to him at movies and translate. We spent the summer with my uncle in Pennsylvania, and in the fall we moved to the International House in Manhattan near Columbia University. Woody had a student visa, which meant he had to enroll in school, so he studied English at Columbia and my uncle paid his tuition. It's not an easy language, but after one year he spoke it well enough to begin looking for work, and I remember the day three years later when he spoke it better than me.

GY __ I know Woody was freelancing as a film editor, especially with studios that produced multiple projection exhibits for trade shows and world fairs. He worked for Francis Thompson and for the photographer Harvey Lloyd, and some others. One of his colleagues at the Francis Thompson studio was Alexander Hammid, the ex-husband of Maya Deren. They made the classic avant-garde film *Meshes of the Afternoon* in 1943. Everyone called him by his nickname, Sasha. Woody and Sasha produced a six-screen exhibit called *We Are Young* for the 1967 World's Fair in Montreal. How did all this affect you?

S __ The good fortune of those jobs was the people we met and the technology we acquired. One of the people was Alfons Schilling, who Woody met in 1966 when they both worked for Ramirez and Woods, architects who did exhibition design. Alfons became a life-

long friend of ours. He was among the Viennese Actionists in the '50s, and in the early '60s he made a dual-projection film about action painting, called *Desperate Motion* (1962), that was projected onto rotating screens. He was the Alexander Calder of cinema. He explored every kind of 3-D imaging, combined with portable projection setups. He called it visual manipulation of space. Shortly before Woody met him in 1966 he made a famous documentary about Nine Evenings, the legendary series of art and technology events that was produced by Billy Klüver and Robert Rauschenberg. We arrived in New York in 1965 to find it bustling with culture. People were using the term "avant-garde." We thought, why are they doing that? The avant-garde was a movement in Paris in the '20s. But then we realized there really was an avant-garde in New York. Alfons was very involved in it, and he became one of our connections to the underground. He's still a close friend.

GY __ When did you get your first studio in New York?

S __ In the fall of '67. That summer I was in Paris studying violin, Woody was working with Sasha at Francis Thompson, and he and Alfons were looking for lofts to rent. Meanwhile they were squatting in a dilapidated building on Front Street where people like Rauschenberg and Lichtenstein had lived before they were successful. It was condemned and had only cold water. Woody found the loft on 14th Street at Union Square, a really nice space which turned out to be just across from Andy Warhol's Factory.

GY __ You were, and still are, very dedicated to the violin. In the five years between when you arrived in New York and when you started doing video, what were the steps that led you away from a career in music?

S __ The most general influence was just being immersed in the avant-garde culture in Manhattan. Within that, certain things stand out: being exposed to all kinds of electronic art through a series of programs at Automation House; discovering feedback and other ways in which the video signal could be manipulated in real time; discovering the possibilities of multi-monitor displays; then taking up the camera and documenting the avant-garde arts scene; and finally having the equipment at home so I could begin a disciplined practice

similar to my daily violin practice. In retrospect, I can see that I was primed, or predisposed, to be open to this new experience by my background in classical music and my early exposure to electronic music.

GY __ So let's talk about the electronic arts program at Automation House. That was a building on East 68th Street that was owned by the United Auto Workers union, and it was the headquarters of Theodore Kheel, a labor mediator involved in the impact of automation on the industry. A woman named Thea Sklover directed the arts program. When did it start?

S __ I found out about it in early '69 and dragged Woody there. Thea Sklover brought avant-garde artists from all over the country, not just from New York City. She was a real mover and shaker, and the program was highly visible. We religiously went to everything. We saw Pulsa, Kenneth Gaburo, Salvatore Martirano, David Rosenboom, Richard Lowenberg, and many others. It seemed to us there was a vast culture of media artists across America. We were sure there were hundreds who were traveling the country presenting their work. All these artists came to Automation House and wired the place from top to bottom and did all kinds of very avant-garde stuff. They were really electronic, and we were fascinated. Even if we didn't talk about it, we were thinking along the same lines — that we wanted to do it ourselves. In the summer of '69 Woody was working for Harvey Lloyd and I went again to Europe. While I was away, the exhibition of video art called *TV as a Creative Medium* opened at the Howard Wise gallery on 57th Street. Harvey Lloyd and his team saw it and decided on the spot to use video instead of film for an exhibit they were designing for the American Can Company. When I came back in September, Woody told me two things: he was doing video, and America was now called Woodstock Nation.

GY __ I understand that Harvey Lloyd bought a lot of equipment which you and Woody were able to explore for your own purposes.

S __ He bought thirty-two monitors, and they designed an elegant Plexiglas encasement to put them in for the exhibition. They had all kinds of production gear and video players to

feed the rows of monitors in the matrix. We experimented with everything. Of course one of the first things we did was feedback, like everybody else. Woody played with what we called "the fire" every chance he got. He'd set up one or two cameras and a monitor and we'd lay back and put our feet up and stare at it endlessly. You point the camera at the monitor and it ignites this streaming, pulsating electronic fire that lashes back and forth without any input from you, as if it were alive on its own, and you know you're in a different space. We brought people in to explore it with us, especially dancers, and we taped some of it. One of the cameras had a switch that let you flip the image upside-down or right and left while you were shooting. That amazed me. It was a revelation about the plasticity of the electronic signal. It was basically a kind of in-camera image processing.

GY __ You and Woody are known for image processing and for switching images around a matrix of monitors. But image processors and matrix switchers didn't exist at that time because broadcasters had no use for them.

S __ But there were custom ones. The electronics engineer George Brown, who we worked with later, made a switcher for Global Village's matrix, but we didn't have one. Nobody had an image processor. The first one ever made, Eric Siegel's colorizer, was in *TV as a Creative Medium*.

GY __ That was the first exhibition of video art in the United States. I saw it and wrote about it in *Expanded Cinema*. Howard Wise was a visionary. He was a generous supporter of media art before most people even knew it existed. He founded Electronic Arts Intermix, and he helped a lot of video artists. I know he helped you start The Kitchen.

S __ Yes, he helped us get our first grant. Two things in *TV as a Creative Medium* impressed me in particular. One was *Einstine* (1968), the videotape Eric Siegel made with his colorizer, which he called the Processing Chrominance Synthesizer. What struck me was just the principle that you could synthesize colors electronically. You could turn black-and-white into color in real time. It wasn't happening live at the gallery, it was just this black-and-white videotape of Einstein's face with feedback that suddenly burst into these unbelievably

vibrant, psychedelic colors. But we knew enough about the electronic signal to realize that it had to have been done in real time, and that was a revelation. The other piece that impressed me was *Wipe Cycle* (1969) by Ira Schneider and Frank Gillette. You stepped out of the elevator, looked down the hallway, and saw a TV monitor on which you saw yourself stepping out of the elevator. That just totally blew my mind. I'd had opportunities to see myself live on closed-circuit video, which, remember, was a radically new experience for most people. But this was more than just closed-circuit, it was closed-circuit on a thirty-second delay. The implications of that just floored me. So those three things — the camera that could flip its live image, the system that could delay a live image, and the instrument that could color a live image — were major revelations about the power of the electronic signal. Combine them with feedback and multiple monitors and it was all there.

GY __ I know you began documenting the rock music scene around that same time, the end of '69. Did you have your own equipment by then?

S __ We had Harvey Lloyd's equipment. His project was over and the gear was just idling in the corner. So, Woody started bringing it home piecemeal, and more and more of it ended up in our loft. A friend of Woody's worked for Bill Graham, photographing concerts at Fillmore East. Woody now had a Portapak, thanks to Harvey Lloyd, so in November the friend brought him along. Woody sat next to the guy in the sound booth and asked, "can you give me a feed?" So he got the house line, and that's why the sound is so good on those tapes. Imagine doing that today, asking them to give you the house mix! Jethro Tull was in November and Jimi Hendrix was on New Year's Eve. I wasn't personally involved up to that point. I thought video was magical and interesting, but I didn't see it as my medium. It was Woody's baby. But the next day, New Year's Day 1970, Woody, Alfons and I were smoking dope in our loft and I began playing with the video camera in a serious way for the first time, and I fell through a crack. I finally understood the beauty of it. It was like falling in love, and I never looked back. As soon as I held that camera in my hand — as soon as I had that majestic flow of time in my control — I knew I had my medium. A few days later Alfons took us to a party on 57th Street which turned out to be Jackie Curtis celebrating the release of his, or her, new song. Everybody was there — the whole Andy

Warhol crowd, Salvador Dalí, etc. It was the beautiful people, with Rolling Stones music playing loud. Just before Jackie was to sing, Woody handed me the camera and said, "you do it." I was scared shitless. I'd never done anything like that. It was a turning point for me; it really got me going. That's when I realized we could go out with the camera and bring in events. We weren't that interested in rock and roll, so we went for the avant-garde arts and the *demimonde*.

GY __ The *demimonde*. A lovely 19th-century term that referred to women of dubious respectability who were kept by wealthy lovers or protectors. In your case they were drag queens "kept" by Andy Warhol. Did you and Woody collaborate equally on this project?

S __ I did most of the shooting. I was totally into it, whereas Woody was more interested in his electronic studio work, so I became the producer. I contacted people and asked if I could tape them, and Woody sometimes tagged along. I did most of the transvestite scenes by myself. We went to La Mama, the Village Vanguard, the Blue Dom and CBGB's, but most of the events were at Judson Church and at the WBAI Free Music Store on 62nd Street, where Pacifica Radio was. They had an auditorium on the ground floor where they presented avant-garde arts – music, dance, experimental theater, all kinds of things. We went every week. It was very lively, in some ways better than Automation House.

GY __ You did this over a three year period until you moved to Buffalo in the summer of '74, and yet you've released only the one-hour compilation called *Participation*. How much more is there?

S __ There's about 76 hours of *Participation* footage, all on ½-inch open reel. But in addition to that are all our studio experiments, social activities like parties and visits in our loft, and our travels to California, Iceland, and Czechoslovakia. A conservative estimate of the total footage from that period, all on ½-inch open reel, would be around 200 hours. When we moved to Buffalo we switched to ¾-inch and halted all *Participation*-type activities. Then in 1977 or '78 we were asked to do a show somewhere, and we hastily threw together a one-hour program that Woody decided to call *Participation*, and that's the tape that is distributed today. We never added to it. Woody called it *Participation* because we were so privileged to participate in such a unique, though short-lived, cultural phenomenon.

GY __ As far as I know, only three people were videotaping the underground culture in any serious way – you, Anton Perich, and Michel Auder.

S __ Yes, Anton and Michel both showed at The Kitchen, and I was relieved to discover that I wasn't alone. I felt strongly that this was an important thing to do, but I didn't want to be doing it the rest of my life. I'm surprised there's so little video of that scene, because everyone was running around with cameras. But the video collectives were more into politics. They wanted to save the world, or at least change it. We had no interest in saving the world. It wasn't our world, it was America, and we still didn't understand it very well. We didn't understand political conventions, which we thought was a weird way to do politics. And anyway we'd had it with politics because of our background under the Communists in Eastern Europe.

GY __ During this same period, you and Woody were doing your studio experiments with feedback and tape manipulation, introducing noise into the image, which was actually quite strange and beautiful, like peering into a phantom world. *The Kiss* is one of my favorites from that that body of work in 1970. You also made *Let It Be* that year, which was the first in the *Violin Power* series. It begins with you playing classical music that segues into the Beatles, then to your vampire mouth filling the screen.

S __ I was making fun of the virtuoso violinist, because that was the last thing I was interested in. I had curls in my hair and I was saying "This is me, the uptight violinist playing virtuoso music." It was the only version of *Violin Power* I did in Manhattan. The remaining footage was done in Buffalo between 1974 and 1978 when we had the Rutt-Etra. The last segment, where I play Bach, was done in '78. All the others were between 1974 and 1976.

GY __ *Let It Be* was very different from what you were doing with Woody.

S __ Woody and I worked together at night, but he had to work during the day and I had time alone. I was supposed to practice violin, but I wanted to experiment with the camera. Woody had a close-up lens. I had taped the Beatles off the air, and I wrote down the lyrics

on a small piece of paper and stuck it on the front of the camera so I could read it while at the same time having my mouth very close to the lens. Everything happened very quickly at the beginning of 1970. I started going to events around town, then came *Let it Be*, and then it was full-time. No more violin career.

GY __ At what point did Woody join you in this full-time dedication to video?

S __ Not long after *Let It Be*. He came home one night and looked at what I was doing and said, "I want to do this. I don't want to work. I quit!" That meant we lost income and we lost our equipment, which belonged to Harvey Lloyd. But we've always been lucky. Just when we needed it, various friends, like Peter Campus, began giving us equipment they weren't using, or sold it to us cheap. So, Woody quitting work was the luckiest thing that ever happened to us.

GY __ You and Woody were among the first to explore transcoding between audio and video, rendering image as sound and sound as image. It's one of your most important contributions to the electronic arts. You have pursued it more extensively than anyone else, and you're still doing it today in your *Violin Power* performances.

S __ The first video equipment we bought was an audio synthesizer. That's how important transcoding has been in our lives. We knew in principle that it was possible to manipulate audio with video and video with audio because they were both electronic signals, but we didn't have access to a synthesizer. Modular, voltage-controlled, patch-programmable synthesizers like the Moog and the Buchla had only been invented in 1963, and they were still pretty rare. Then in early 1970 I saw an ad in *The Village Voice* for an electronic music studio for hire. We called and explained what we wanted to do, and were told that the studio was above the Bleecker Street Cinema, that it had a Buchla synthesizer, and it was $20 an hour. In the '70s that was a bloody lot of money, so we could only afford one hour. We brought our big open reel video player and a monitor and cables, lugged it all upstairs, and paid the young man our $20. He showed us the different modules on the synthesizer and how to patch them together, then he left and he didn't come back for three hours. So we

got extra free time, which we desperately needed. We tested our idea in only one direction, video to audio. We used the video signal to voltage-control the oscillators in the synthesizer, and it worked beautifully. It was confirmation that a new artistic practice was possible. For us it was a major watershed that opened up a whole new world. It was one of our most heartfelt discoveries. We had to find a way to continue, but we couldn't afford $20 an hour. We needed our own instrument. As luck would have it, a couple of salesmen from the British company Electronic Music Studios (EMS), were in town selling their EMS synthesizer, a well-known and much-loved instrument that Brian Eno, and lots of other people, used. These guys had brought over a few machines from London. Through the grapevine they found their way to us, and we bought an EMS for $5,000. That was a lot of money in 1970, but it was so much less than anything else, and the machine was available, whereas each Buchla or Moog was made to order and they cost a fortune.

GY __ Where did you get $5,000?

S __ From my father in Iceland. I told him, "We are into something very important and we really need this machine." My father was an incredibly gracious man. He said, "I'll send you $5,000," just like that. A few years later I mentioned that I still owed him the money. He said "No, you don't. I gave both of your sisters $5,000, so we're even." He died shortly thereafter, and we discovered he had no money.

GY __ The 14th Street loft was the first of the now legendary Vasulka studios. You were producing a lot of work. Did you have screenings there? Were you trying to create a "Kitchen" kind of scene before you started The Kitchen?

S __ We weren't trying to do anything, it just happened. Every night tons of people came to our loft to see the instant playback. It was a new experience. Even the word "video" was new. Different audiences came to our screenings. The people who came to see themselves in some performance we had documented, or the people who came to see the Fillmore tapes, were not the same people who came to look at our electronic work. The rockers loved to see what we were doing. The word got out somehow. This was the '60s and the

Village was very small and everybody knew everybody, so they just showed up. They knocked on the door and said, "We're here. Is it true you have Jimi Hendrix footage?" and they lit up their joints. We weren't citizens yet, so we could have been deported, but that didn't bother us.

GY __ Did you have shows in public venues?

S __ Oh yeah, but we did them ourselves. They weren't in galleries or museums. Everything was a do-it-yourself underground kind of thing, in the same places where I had been documenting the avant-garde arts, like Judson Church and the WBAI Free Music Store. We'd call them up and ask if we could do a show. They were totally open to us because they got a show without having to do anything. Remember we had monitors and we had friends with matching monitors. We got expensive Setchell-Carlson studio monitors from Aldo Tambellini. Big 25-inch black and white monitors in wooden cabinets that produced a beautiful black. Everyone loved them, and we had them at The Kitchen later. We could fit four of them into one of those big Checker Cabs, and also ourselves, and we went all over Manhattan and Brooklyn. At Judson Church we had fifteen monitors in a long row. It was the usual scene – sitting on the floor, marijuana in the air. We played these endless tapes and nobody left. We also did a show at Global Village, where they had their own matrix of monitors, but our other peers in the video collectives, like the Videofreex, Raindance, and People's Video Theater, didn't want us. They only wanted to show their own stuff. But as soon as we had The Kitchen, they all wanted to show there. We were very visible and we had a different audience.

GY __ What was your first gig?

S __ It was in February of '71 at Max's Kansas City Steakhouse on Park Avenue, in the nightclub above the restaurant. There were three nights dedicated to the three kinds of work we were doing – image processing, gay cabaret, and the rock concerts.

GY __ That was a real coup. Max's was a legendary hangout for artists of The New York School, like John Chamberlain, Robert Rauschenberg, Larry Rivers, and also musicians,

poets, politicians, celebrity jet-setters, and Andy Warhol's entourage. The Velvet Underground did their last shows with Lou Reed there in the summer of 1970. I was there several times because it was just up the street from my publisher, E.P. Dutton. It was a totally different scene from Judson Church. How did you arrange it?

S __ We knew they'd had a five-monitor installation by John Chamberlain, and that the monitors were still there, so we asked Mickey Ruskin, the owner of Max's, if we could do a show. He said yes without batting an eye. Everything was so casual. We filled the space all three nights, and the audience was mostly transvestites who were screaming and yelling. We made something like $60 a night, but Mickey never took his half because he made so much money on drinks. When the shows were over we asked if we could buy the monitors. He wanted $100 apiece. We could only afford three, but when we opened The Kitchen four months later he loaned us the other two for free. We had a running tab at Max's Kansas City. We could eat there and just sign for it, and in the mail once a month came a bill. A lot of people did that – they ran up a bill. It's not done like that anymore.

GY __ Why did you start The Kitchen, and how did you do it?

S __ We started it for two reasons. One was to reclaim some kind of privacy. There was so much traffic in our loft, all these people coming and going, and we were longing for privacy. Meanwhile we were dragging those big monitors around the city doing shows, wishing we had a permanent venue where we could showcase our work. Andres Mannik, a carpenter who renovated lofts like Merce Cunningham's, came to all three of our shows at Max's Kansas City, and after it was over he said he could get us a space. His passion was modern dance and he was dying to open a theater, but he didn't know how to do it, so he got us with him. He saw The Kitchen as a dance and performance space, and he was willing to pay for and supervise whatever renovations might be necessary. He had renovated spaces at the Mercer Art Center, an aggregation of off-Broadway stages, cabarets, and actors' studios on the first two floors of the Broadway Central Hotel at 240 Mercer Street. It was a grand, 19th-century hotel that had declined into a flophouse with more cockroaches than people. The space Andy found for us was the abandoned kitchen of the hotel, also on the

ground floor. On the other side of the building, on Broadway, was a bar called St. Adrian's, a popular gathering place for artists in an area that people were starting to call SoHo. Apart from Max's Kansas City, St. Adrian's was the hippest hangout in Manhattan. So the location was ideal for us. It was a real scene. Seymour Kaback, the entrepreneur behind the Mercer Arts Center, said we could have the space rent free for a while in exchange for renovating it. No contract, just a handshake. We didn't know what "a while" meant, but we went ahead and fixed it up beautifully. Andy Mannik took out the old stoves and the big refrigerators, laid down a new wood floor, and created a space of elegant utility — exposed brick, floor-to-ceiling blackout curtains, sound-proofing baffles, and an open floor space where equipment and seats could be arranged as needed. It was so beautiful that Seymour wanted rent. We finally opened The Kitchen in June of '71 with Automation House as our model. Their series ended in 1970, and we wanted to be as magnificent as they had been. We were certain we were just one of many venues of this type in New York, so we felt grateful and humble when The Kitchen became so successful. Only later did we realize that all these people had been orphaned. We were immersed in our work, so we were unaware that every other venue had closed. Media artists had nowhere to go. We became the place because we were the only place. So we saw to it that media culture in New York remained rich.

GY __ You certainly did. The Kitchen as we know it today has long been the premiere presentation space for avant-garde art in the U.S. But your version of it was much more than a presentation space; it was a laboratory. You called it The Kitchen Live Audience Test Laboratory. The laboratory approach was not only appropriate to the historical moment, it was visionary. The Internet has become a global laboratory for public acculturation of emerging technology, and it exhibits many of the characteristics of The Kitchen. The entire facility was itself an instrument, a meta-medium for exhibition, exploration, collaborative exchange, sharing of resources, creative conversation, and camaraderie. It was a great gesture of generosity and a great service to the media arts community.

S __ We knew we were making history. There was no question about it. This was the beginning of a new era and the world would never be the same. Woody and I were the

directors-at-large, and people volunteered to organize programs. Rhys Chatham launched a Monday night series of electronic music concerts and published a calendar. La Monte Young was the opening event. We wanted him to do a live performance. He said, "I don't perform for free, but I'll do it as a release party for my new LP." We put an ad in *The Village Voice* and filled the house. La Monte looks so impressive you know, like a rabbi or something. He's a descendant of Brigham Young. So here was this Mormon just sitting there, very imperious, listening to his own LP being played on a turntable. After that the music program just took off. Shirley Clarke started the Wednesday night open video screenings, where anyone could show their work, and Dimitri Devyatkin and Shridhar Baphat coordinated other video events that included documentaries on social and political issues. None of this was curatorial; we refused to curate. We just trusted people. Sometimes they weren't very good, but so be it. The Kitchen was an open space for everybody. We had an excellent sound system, twelve monitors, and people brought copious amounts of other electronic equipment. The fun was to hook it all together and make one thing affect the other, because it was all new. It was all being invented. The audio and video synthesizers were just coming out. They were all brought into The Kitchen at one time or another, and we were always willing to do tech for everybody. There were lots of live performances. Bill Etra and Walter Wright brought in musicians to control their synthesizers, or they pointed cameras at the audience and processed the image in real time. It was improvised, like free jazz, and they liked to jam. It was our fun, our way of communicating, of being in there and being part of it. It became our life, often seven nights a week. If nobody showed up for the Wednesday night open screening we'd do it ourselves, even if there were only three or four people as an audience. We prepared backup programs for that purpose, mostly our own stuff. But eventually so many people wanted to show that it went on past midnight. It was up to the presenters to decide whether or not to charge admission. If they did, we had a loose agreement that they could take the gate, they could give it to us, or we could split it. Ninety-nine percent of the artists gave us the whole gate. That's the kind of generosity there was. They understood that we had printed the posters and things like that. But also, The Kitchen was a live audience test laboratory and a lot of people didn't want to charge admission because they were experimenting, they were trying out ideas. So even when they did charge, it was usually on a donation basis.

GY __ What happened to The Kitchen? It was such a vital force; why did it close?

S __ In the summer of '73, the owners of St. Adrian's decided to remodel. This involved removing some columns, and after a while we began to hear creaking sounds. It became evident the building was collapsing – they had taken out one column too many. The Kitchen closed in July because Seymour Kaback wanted the space, and a month later the entire Broadway wall collapsed and three or four people were killed.

GY __ A year later Gerald O'Grady invited you to teach in Buffalo. He was starting a new program at SUNY called The Center for Media Studies, which became one of the most renowned New Media programs in the U.S. The faculty eventually included Paul Sharits, Hollis Frampton, Tony Conrad, Peter Weibel, and the Vasulkas, plus numerous visiting artists and professors. I taught there for two summers. O'Grady was also director of an off-campus independent facility called Media Study Buffalo, an enormous space in an abandoned hotel in downtown Buffalo, where there were New Media workshops and residencies, and regular screenings of experimental film and video curated by Bruce Jenkins. Those two programs were a unique moment in the early history of New Media. You and Woody have spent the last several years curating and designing a major exhibition about it for ZKM in Karlsruhe, Germany, which is under the direction of Peter Weibel. Tell me about going to Buffalo in 1974.

S __ Gerry O'Grady was teaching simultaneously at SUNY Buffalo, at Rice University in Houston, and at Fordham University in New York City. Through Rice he met John and Dominique de Menil. People always talk about Dominique, but it was John who was the visionary. He grew up poor and married into the de Menils, so he knew how to spend money. He gave Gerry a blank check to design a media arts curriculum and do a trial run for one semester at Rice, but Gerry convinced him there would be more support for it in Buffalo. So now Gerry was shopping for ideas and faculty. We no longer had The Kitchen, but he found us through the grapevine and brought his Fordham students to our loft. He more or less ignored me but he fell in love with Woody, and from that point on he was

determined to bring Woody to Buffalo. He offered us a twelve-week residency at Media Study Buffalo that fall. We subleased our loft and found an even better one in Buffalo on a month-to-month basis. Meanwhile Gerry was assembling a faculty for the trial run that spring of the new curriculum that John de Menil had funded. It would be a "no-show" kind of job where Woody would have to do almost nothing, so we stayed, and during that semester Gerry offered Woody tenure. "Ten years in Buffalo?" said Woody in all serious-ness, "No way!" We needed the money and we had no reason to go back to Manhattan that soon, so we agreed to stay on a while. But disappointing experiences with students and no time to do his own work caused Woody to hate teaching. He wanted to teach only one class or he was going to pack up and go home. Gerry couldn't pay me to teach the other class because a husband and wife weren't allowed to be on the same faculty, so I did it for free for the next two years until we moved to New Mexico in 1980.

GY __ So the academic side of your life in Buffalo was difficult, but at the same time both of you did your most important work in those five years.

S __ See, New York was just a party. From the moment we arrived in 1965 it was a party. At first we were only with other foreigners. Then when we got into video we were with the Americans. They became our colleagues and we started speaking in English. Before that we spoke usually in Czech, so we changed the language and it became another kind of party. The Kitchen was a party too, you know, like every day. Then we came to Buffalo and we got this huge, beautiful, well-heated loft. A lot of quiet, private space where, as you say, we did our most important work. Woody did serious studies there with the Rutt-Etra scan processor, and we had a couple of brilliant students who taught us about digital everything, from hardware to software. I've often wondered if we would have accomplished the same things if we stayed in New York. Would we have had time for that kind of focused concen-tration? If we had a dog or a child or even a carpet we'd amount to nothing. But we had endless time. It was time that made us what we are. We got lost in our work in that huge space in Buffalo. At certain moments I would become aware that Woody was standing next to me asking if I wanted something to eat, and I would realize that we had been working for hours, totally oblivious to one another. He was over there and I was over here, and some-times we met.

GY __ Between meetings you produced pivotal works like the *Violin Power* series, the *Orbital Obsessions* experiments, and the first *Machine Vision* installations. You systematically explored image processing with the Rutt-Etra Scan Processor, which involved extensive transcoding of image and sound, and you used George Brown's multikeyer and flip-flop switcher to automate the cutting and combining of images. To move beyond the capabilities of those instruments, you built the Digital Image Articulator with Woody and Jeffrey Schier.

S __ The Digital Image Articulator was a three-way collaboration. Jeffrey designed it, Woody built it, and I raised the funds for it and documented it. We worked nonstop for eighteen months starting in 1978. It was an enormous effort.

GY __ Woody used the device to extend his exploration of what he called electronic syntax into the realm of digital code. You were interested, but it was his project. Was there a conscious effort to separate yourself from Woody?

S __ No. Neither of us was interested in separating ourselves. We were perfectly happy with nobody knowing who did what. A lot of the time we didn't even know ourselves. But when Woody started on the Rutt-Etra, I wasn't that interested and I became kind of lonely. I was very interested in mechanical and optical things, but Woody wasn't. He had worked with machines and motors and gears as a kid, and had experimented with the optical elements in film school. So it was nothing new and exciting for him, whereas the electronic signal was. Of course he had to be my teacher because I didn't know a thing about gears and AC-DC power, but he wanted to have minimal involvement. He would say, "Woman, just do it yourself!" That's when we started spreading out. We haven't actually done collaborative work to any extent since 1974, just after we moved to Buffalo. We split our interests. Everyone thinks we're these model collaborators. Art historians dream about ideal collaborations – two minds that make one work. I just don't believe it's true. It's always one mind that takes the lead. In our case it was kind of fluid. I'd set something into motion and Woody would come and perform it and record it. So it was always one who had the idea and the other who was the assistant.

GY __ The early '70s saw the rise of the second wave of feminism in the U.S., in which video played an important role. You were seen by many as, if not a feminist, at least an emblem of an independent woman carving out her personal path in the man's world of high technology. I don't know how feminists saw you, but from my point of view you never miss an opportunity to speak up and point out when something sexist is said or done. You have kept me alert for thirty-four years. And yet you insist you're not a feminist.

S __ That doesn't mean I'm against feminism as such. I just have no interest in framing my work or my life in those terms. Feminists at that time were interested in stuffed animals. Embroidered hearts with stuffed animals next to them, and a lot of rhetoric. I didn't come from that kind of environment. It's like, every so often you meet a black person who didn't grow up black. They didn't know they were black. I remember Harry Belafonte describing this. He grew up in Jamaica and it wasn't until he came to New York and was denied access to the theater in which he was going to perform that he realized he was black. I had a similar kind of upbringing. I didn't know I was a woman, in the sense of being inferior to men, or living in a patriarchy. I lived in a matriarchy. I grew up in a family where women are very powerful, and have been for centuries. I'm the third generation in a family of professional women who partially support the husband.

GY __ So your objection to feminist art is primarily aesthetic.

S __ Yes. In trying to go as far into womanhood as they possibly can, they lose sense of what the art is. It's a cheap trick in a way. You reach your sisters on the most superficial level. So what? You have to go deeper into whatever this magic is that's called art, and that is seldom done in political work. I'm *a priori* against political art, but that's not to say that some of it isn't very successful. Even if you go back centuries, like Mozart's *Marriage of Figaro* was incredibly political and shocking at the time, but what do we care about that now? We only care that he wrote fantastic music. Some feminist art is very interesting as art, but that's because those women are artists to begin with. I did something for the feminists at The Kitchen. When there was some kind of festival or series there, it was always boys. I was the only woman, or maybe there were two or three of us. It irritated me, so I

started a Women's Video Festival. I thought it was important because there were a lot of good female video artists. Ironically, some felt they shouldn't participate, or that I shouldn't be among them because I was too technological. I thought to myself, maybe they should become more technological if they wanted to get out of their predicament.

GY __ The Vasulkas were supported by grants from every source in this country for a couple of decades, but it's my sense that you fell out of favor when art got politicized in the '90s because you were perceived as apolitical formalists.

S __ I don't feel we've been discriminated against because our work isn't political. I've always been very flattered by the fact that if we sent out a grant that was judged by a panel of our peers, we got the grant. We got a lot of them, so in that sense we were extraordinarily lucky. But when it comes to the art world we're labeled "techies," and nobody wants to touch us, especially collectors. We've never been collected. That doesn't bother me, because I'm not that interested in them either. So in other words, we've been supported for the right reasons, hopefully.

GY __ I'd like to talk about the role of sound in your work. Our mutual friend David Stout suggests that in using the video signal to control audio, you and Woody were among the first artists to exalt in "machine noise," which has become a cult preoccupation among young sound artists today. The loud, percussive, noise-like quality of sound in your work is actually quite effective. It drives your landscapes and waterscapes beyond lyricism into the terrible beauty of the sublime. It's your signature as an artist, and yet it's so radically different from your love of classical music.

S __ I'm totally against using any kind of pre-recorded music with electronic images. Either no sound, or ambient sound, or the sound that the electronic signal itself makes. Sound is always stronger than image, and to prop up the image on someone else's genius, that must not be done. I used classical music in *Sound and Fury* (1975) only because it was on the radio in the background and it was totally influencing my state of mind and what I was doing physically. I was dancing to it. But the electronic oscillation is still foreground, and the contrast between the two is what gives the tape its power.

GY __ One of your most unique *Violin Power* performances was a telepresence event that Mort Subotnik produced for Electronic Café International in Santa Monica in 1992. The Electronic Café was run by Kit Galloway and Sherrie Rabinowitz, who were pioneers of what used to be called telecommunication art. It was a network of people around the world who used various technologies for multimedia tele-collaboration. Multimedia meant seeing and hearing over distance. It wasn't the Internet; they used ordinary voice-grade telephone service to send and receive video and audio, using a range of technologies from high-end video-conferencing tools to slowscan videophones that transmitted six or seven black-and-white video frames per second. They were actually marvelous devices with their own unique aesthetic. You could project them onto large screens and fill the space with speakerphone audio. This event was a demonstration of MIDI controllers. Mort was in Santa Monica using data gloves to play a piano there, and you were at Studio X, an Internet service provider in Santa Fe, using your violin to play the Violin Power laserdisc in Santa Monica. In a typical Electronic Café event, remote locations would be connected by four phone lines — two for sending and receiving video, two for audio. There would be two projection screens at each end, one showing the image that was being sent, the other showing the image that was being received. But Studio X had only three phone lines. You used one to send the violin MIDI code to Santa Monica, another to send slowscan videophone images of yourself play-ing the violin, the third to receive audio from Santa Monica. So the audience at Electronic Café International could see you but you (and the audience in Santa Fe) couldn't see them. You could hear the laserdisc audio over a speakerphone, so at least you knew it was work-ing. When you played a certain pitch on the violin and heard the corresponding sound from the laserdisc soundtrack, you knew the image track you wanted had come up. The full experience was unfolding only in Santa Monica, and the video documentation of the event captures it vividly. The audience saw two large projections: you playing your violin live in Santa Fe at age fifty-two, and you playing the violin twenty-two years earlier when you were thirty. In essence, you are reaching out across space and time to touch your younger self with your telepresence. It's haunting. You're so close, yet so far away. The videotape conveys the power of that moment. It was a beautiful idea and a poignant experience that transcended the technology.

S __ The reason I know it was successful and convincing was that a little later I saw David Berman and I said, "David, I haven't seen you in so long, years and years!'" And he said, "But I saw you in Santa Monica a couple of months ago." He had seen me on the screen and assumed that I must have been there in that space.

GY __ Your first installations used multiple monitors. Projection wasn't viable at that time so everyone used monitors, but no one explored their potential as extensively as you and Woody. You explored all possible configurations – matrixes, stacks, rows, rings, random spatial distribution, even a long asymmetrical arch, which I thought was particularly beautiful. It wasn't just configuration, it was also the kinds of visual dynamics that were most effective for a given arrangement, like different ways of moving images around a matrix. Your most important discovery was "drift," where an image seems to move from one monitor to the next across the space between them, horizontally or vertically.

S __ I said the first video instrument we bought was an audio synthesizer. In a similar way, our first display was not one monitor but three. We never went shopping just for a single monitor. We saw video as multiple images from the beginning. We were very inspired by having bought three monitors from Mickey Ruskin at Max's Kansas City, and not one. On a single monitor, drift is just a mistake, a flaw, but on multiple monitors it's a revelation. That's another example of how one is inspired by one's tools. We saw horizontal drift for the first time on three monitors. It was accidental, the result of a bad cable. But the unintended amplification of the drift – that it came shooting across three monitors – transformed a flaw into an aesthetic strategy. It inspired us to modify monitors so they'd roll horizontally, vertically, even diagonally.

GY __ You used *Pyroglyphs*, the fire tape you made with the metalwork artist Tom Joyce in 1995, to create one of the most beautiful multi-screen arrangements I've seen. You presented it on a circle of thirteen 27-inch monitors that were tilted up about 45 degrees, sitting on the floor in your studio. That was stunning. Talk about a ring of fire! I feel privileged to have seen it, because you never showed *Pyroglyphs* in that configuration in Santa Fe.

S __ Configurations are determined by what's available. I wanted to use *Pyroglyphs* for a show in Prague. A ring was the obvious configuration for fire, but I didn't have enough matching monitors. I finally got them from the Museum of Fine Arts (now the New Mexico Museum of Art) here in Santa Fe. They had purchased an installation by Meridel Rubenstein and Ellen Zweig called *Critical Mass*, done in 1993. The show was long over and the CRT monitors were in storage. One of them wasn't working, and for some reason they asked me to test it. I said to do that I had to have them all. It was a lie, but they agreed. So now I had this spectacular ring of matching monitors in my studio that I could experiment with. It was such a luxury. It was the only time I edited a work for a specific configuration. The ring was an instrument, and it became the inspiration for what I was doing. I would make an edit and play it on the ring and either keep it or go back to the drawing board. One version was a drift that turned the ring of fire into an orbit of fire. You can't find matching CRT monitors any more; they're gone.

GY __ Beyond rings, you frequently use spherical objects and images, and you keep returning to them in different ways.

S __ It's the most perfect form on earth, or in the universe maybe. There's so much of it. It's everywhere — in us, in our bodies, and outside us. You're always dealing with it — galaxies, or flowers. It's all spherical and things that spin around. Geometrical shapes pale in comparison. A ring is already a very magical form, but when the ring turns three-dimensional, begins to rotate, becomes an orbit — I can't think of anything more beautiful.

GY __ When did you first use projection?

S __ For *Borealis* in 1993. It was important to me to have multiple screens and not to project on a wall. I was so used to multiple monitors that a frontal, single-image projection was unacceptable. The screens had to be free-standing objects that one could walk around, and the projection had to be as unobtrusive as possible, so that the screens appeared to glow on their own. We became totally obsessed with finding screen material that was both transmissive and reflective, so it could display an image on both sides, and how to use

beam-splitting mirrors so that we didn't need a projector in front of every screen. Some screen materials were 40/60, meaning dimmer on the back than the front, but we finally found a 50/50 vellum. It was the same situation with beam-splitters. Some reflect more light than they transmit, and vice-versa. We had to find ones that were 50/50. So I multiplied the number of images with front and back screens that people could walk around, and I multiplied them again by splitting a single beam with the mirrors. I got four screens from one projection and there were two projectors, so I had eight screens. I used dichroic beam-splitters, which means that the reflected and transmitted beams will be different colors. The reflected beam will be reddish and the transmitted one will be bluish. The result was that my color image became even more unreal.

GY __ You speak often about how you're inspired by the potential of some technology, but you rarely talk about aesthetics.

S __ See, it's kind of embarrassing, because when I get into something good, something I really like, I drop my jaw and go into this staring moment. I did it as a little kid. I am totally mesmerized when I look at something, be it flickering flames or a camera that moves this way and then that way. It comes up on me, and that's how I select the material I want to work with. It has to have that quality. Sometimes I see that other people have the same trance-like response to my work, and that's really what I'm after. I want people to forget space and time and just look. I want them to live for a moment in a world where they've never been before.

GY __ There's a powerful sense of place in your landscapes in spite of the percussive and fragmented way you render them, or maybe because of it.

S __ Place has a far more central role in my work than I ever thought. I used to think that whatever I captured through the lens was just raw material, just an object detached from its place. But then I started thinking, I'm lying, it isn't like that. Place is very important. The Southwest is very important to me, but it's nothing compared to Iceland. I see myself as a young girl looking out of the window down at this landscape and my eyes fill with tears. I

cannot believe it's so beautiful. These of course are the tears of childhood, you know, evoking this old feeling. So in that sense my landscapes are autobiographical.

GY __ Looking back, are you aware of specific influences on the content and style of your work over the years? Other artists or artistic practices, for example?

S __ I've been through this in my mind many times. I saw an interview with Bill Viola in which he cited all these influences — Giotto was an influence, Zen Buddhism was an influence. I thought, what were mine? Did I have any? I was steeped in art and culture, but when it comes to naming influences I draw a blank. There are very few, and they are much more hidden. They're not straight out there. Of course Bach and Beethoven were huge influences, in the sense of understanding compositional structures, and what architecture is in music.

GY __ Do you have favorite works? And if you do, what are your favorites in each format — single-channel, multiple monitor, and projection?

S __ It's difficult to name favorites because you love all your children. In my single-screen works *Lilith* (1987) stands out. It proved me wrong. I made it slower and slower thinking it would become boring, but the slower it got the more dramatic it became, as if her voice was the wind moving the trees. It puts you in an altered state. Of my projection environments, *Borealis* is a favorite because it has an opposite kind of power. I made it in Iceland for a show using the beam-splitters and free-standing screens. I wanted to evoke the primal power that Iceland has for me. A friend came out of the room and said "I got queasy. I lost my balance." I said, "That's wonderful. It served its purpose." He was surprised. Later in Santa Fe I showed it on columns of black and white monitors. Again a friend said, "I have a hard time watching this because I lose my balance. I feel nauseous." So it got reconfirmed. I don't think they meant it as a compliment, but I took it as one. The piece must have a certain power if people can feel that way about it. Of my multiple monitor works, *The West* is probably my favorite. I didn't really want to make it, but Patrick Clancy, the curator who

commissioned it, wouldn't take no for an answer. He kept pushing me, and it turned out to be pretty spectacular on that ring of monitors.

GY __ People think video art lives in museums, but in fact there's an enormous global network of international video festivals and New Media festivals that, in a given year, surely must dwarf the number of museum exhibitions in sheer volume. It's a parallel universe with a whole different ethos around art. It operates more like a gift economy in a way. Your long and ubiquitous presence in that world explains why you're so legendary in spite of being essentially ignored by the international museum/gallery axis.

S __ I'm invited to a lot of festivals, and I'm grateful for that because they're a gas. They're wonderful human gatherings. You meet a lot of colleagues and it's great fun. I almost never have museum shows. In the United States, since I came to Santa Fe, I had a show with Woody at the San Francisco Museum of Art, and one at the Guggenheim Annex in New York that traveled to Mass MoCA, and that's it. The rest have been out of the country, and almost always at festivals.

GY __ Another thing you've done outside of the U.S. is to continue your involvement in tool-building. The early audio and video synthesizers were user-built folk instruments, and you and Woody, more than anyone else, brought them to the attention of the world. Then you built your own device, the Digital Image Articulator. Today's user-built folk instruments are software, and you continue to be on the leading edge. In 1997 you were director of STEIM, the Studio for Electronic Interactive Music, in Amsterdam. You collaborated there with Tom Demeyer in the development of Image/ine, an entire video synthesizer in software, which had never been done. You played a significant role in the evolution of that particular program.

S __ A video synthesizer in software was inconceivable because computers were too slow to do those things in real time, except maybe for high-end workstations that nobody could afford. I thought it was nice that Tom would try but, like everybody else, I thought it was impossible. Affordable computers simply weren't that fast. But when he showed me

real-time displacement – which is when you use the brightness level of an image to lift or sink parts of it, so that there's a secondary image – I totally jumped. Two years before, Woody had made a ten-second segment that took eight hours to render, and here was Tom doing it in real time. Analog machines like the Rutt-Etra did it in real time, but the problem was to do it digitally. To digitally process anything in real time was out of the question. This was the first time it was done in software. It was an unbelievable break-through. All the VJ's and multimedia performers do it now through real time digital manip-ulation of the image. It allowed me to replace the laserdisc with computer memory. Instead of using the violin to address video frames on an analog disc, I address specific locations in a digital database. The digital revolution is both a blessing and a curse, because when the new technology comes out I always feel like I wasn't finished with the old one. I didn't do all I wanted to do with analog tools and suddenly the world turned digital on me. So there's always the sentiment that everything went too fast and I didn't get to do all I wanted to do, combined with the attraction of more and more new tools to investigate. But that's getting very difficult because there are so many steep learning curves. It bothers the hell out of me. I'm very slow to master new tools, and I look with envy at the kids who take to it like second nature.

GY __ What's your next project?

S __ I've been going back and looking through footage I shot all over the world. I have hundreds of hours of material, recorded over many years. I taped every festival I went to, and I documented an entire year of work at STEIM. Right now I'm primarily looking at Iceland and Japan. There are sixty hours just of Japan. So I think I'm going to retire and sit in a nice chair and edit all this stuff. A kind of capture in time of what was happening. They're the things I regretted not being able to finish because the technology was running too fast. So maybe now I'm going to stop technology right there. It can go into a hole as far as I'm concerned. Looking back is partly about the question "Who am I?" That's some-thing I've asked myself all along, because it's what video has been for me. It has been a

reflection in which I could see myself as I was, or as I was not. I look at things I did twenty years ago and I say in amazement, "Who was I then? And why did I do that?" This continuous dialogue with myself is a very large part of why I stayed with video, why I have always found it so endlessly fascinating.

Plates: Single-Channel

Participation, 1970-71

Steina and Woody Vasulka

Participation is one of the earliest collaborative works produced by the Vasulkas. This rarely exhibited video is an assemblage of short films shot on location at The Fillmore East, the former CBGB's nightclub, and other underground performance venues in New York City. Though straightforward in their documentary approach, these grainy black-and-white videos capture a range of extraordinary personalities – many of whom are considered legendary today – and the wildly experimental atmosphere produced during the late 1960s and '70s by neo-avant-garde artists working in New York's Lower East Side. These selected vignettes describe a zeitgeist singular to the era: luminary jazz greats Miles Davis and Don Cherry appear, as do Candy Darling, Paul Morrissey, Taylor Mead, and Jackie Curtis – stock stars of Andy Warhol's Factory scene. Sex, drugs, and rock n' roll figure prominently in *Participation.* In one portion of the film, for example, we see superimposed footage of a male and female dancer engaged in electronic sex acts set to James Brown's iconic "Sex Machine." The camera records the visceral intensity of concert performances by Jimi Hendrix and Jethro Tull, as well as Steina's comical lip-synching to a pirated copy of the Beatles' 1969 version of "Let It Be."

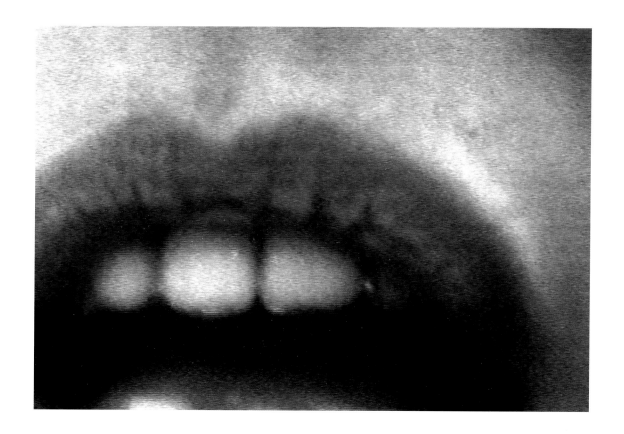

stills from *Participation*, 1970-71

Flux, 1977

Steina (unless otherwise noted, all works by Steina)

During the 1970s, Steina and her New Media artist peers began experimenting with
newly engineered machines that could manipulate footage previously captured on video-
tape in real time. *Flux* is an early example of Steina's experimentation with such break-
through technology. Using a Time Base Corrector, which allowed her to "switch" between
two different sources of input, she created a viscerally jarring video that switches, at an
uncomfortably high frequency, between images of water, cars, and the landscape. The
strange sounds accompanying the rapidly strobing images are generated from Steina's
manipulation of the electronic signal, which lends the piece its eerie, other-worldly quality.
Flux also demonstrates Steina's singular ability to apply musical techniques, such as
counterpoint, to video technology. As with counterpoint, Steina used the switching move-
ment to create a series of contrasts — still versus moving images, the natural versus the
artificial landscape, or representational versus abstract elements — that, despite their
differences, establish a harmonic relationship.

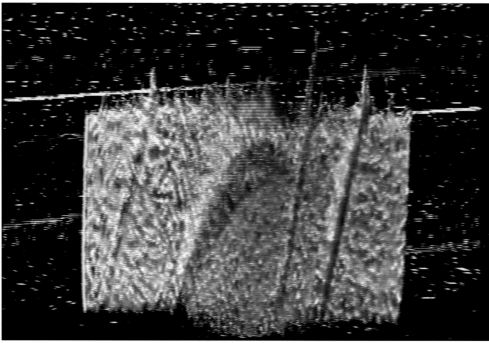

stills from *Flux*, 1977

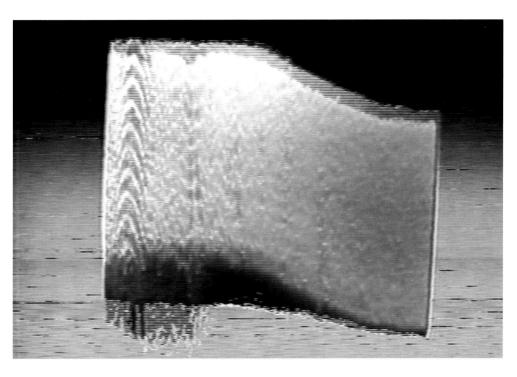

Orbital Obsessions, 1977 (revised 1988)

While living in Buffalo, New York in the mid- to late-1970s, Steina began developing *Machine Vision*, a project that consists of installations and videotapes that used mechanized modes of camera control in order to address human perception. *Orbital Obsessions* is part of *Machine Vision.* This work, which is also a compilation of videotapes, reveals Steina's continual experimentation with new imaging devices and exploration of electronic space. In *Orbital Obsessions,* Steina challenges the view that the camera lens is an extension of the human eye and attempts to create new ways of "seeing" by situating cameras on different automated devices. For example, in one section of the tape she mounted a camera on a turntable that moved 360 degrees horizontally; in another section she placed the camera on a rotating wheel that moved 360 degrees vertically. Steina also used rapid switching, video wipes, and delays – which often create ghost-like effects – to complicate any fixed notions of time and space.

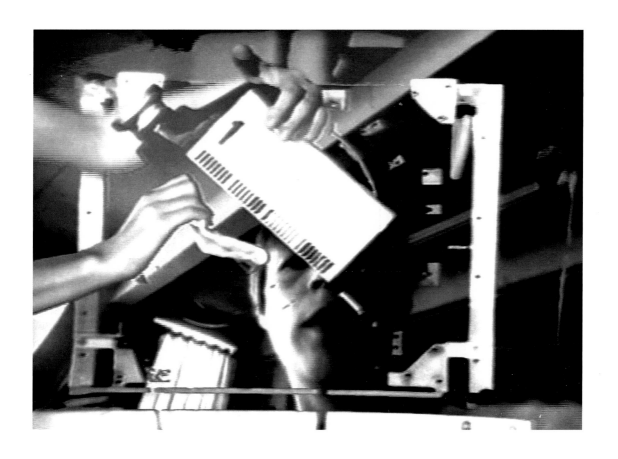

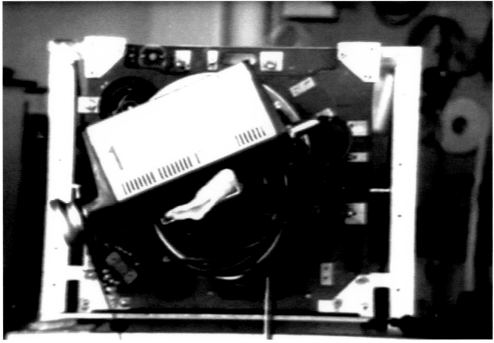

stills from *Orbital Obsessions*, 1977 (revised 1988)

Cantaloup, 1980

Cantaloup is Steina's unconventional "how-to" documentary about the construction and function of the Digital Imaging Articulator – an early electronic digitizing device designed in 1978 by the Vasulkas and a computer scientist, Jeffrey Schier. In *Cantaloup*, Steina, using one of her favorite objects, the sphere, casually narrates the complex process of digitization. For example, she describes how the computer "slices" the image of the sphere (think of the sphere as an onion with individual layers) into numbers that correspond to its varying light values. By inserting radiant colors into the image, Steina reveals the various strata and densities of these sections. We see its effects as the image pulsates with rings of color. Throughout the tape, she uses simple images to explain the complex applications of electronic image transformation. Pixelated hands and colorized faces, as well as multiplied images of Steina's face, were created through a "grabbing" technique. Although formally speaking the serialized portraits resemble a photographer's contact sheet and the compositional strategy of repetition as employed by Andy Warhol, the multiple images of Steina were created in real time. At various intervals, she inserted sound into the piece, harnessing the electronic noise generated by the video feedback into short, innovative compositions.

stills from *Cantaloup*, 1980

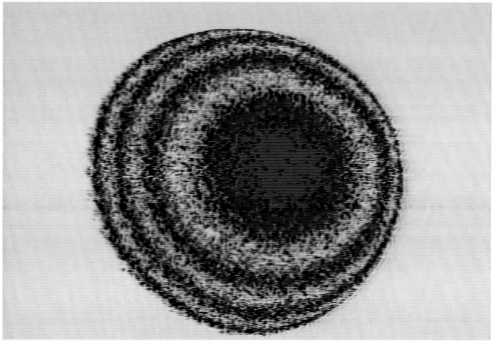

Urban Episodes, 1980

Urban Episodes is one of Steina's first public art installations, and the resulting videotape is a document of the work as seen in a public plaza in downtown St. Paul, Minnesota. As with her earlier *Machine Vision* project, Steina used mechanized cameras and surveillance techniques to create new modes of seeing that go beyond the limits of human perception. For *Urban Episodes*, Steina constructed a machine that has a continuously rotating turntable and a long, horizontal platform. She affixed the camera – equipped with a mechanized, rotating zoom lens – on one end of the platform, and then placed a variety of objects in front of it on the opposite end. The "episodes" in the tape are differentiated by the optical devices that Steina placed in front of the camera. In one segment, she attached a semi-transparent mirror that tilts up and down; in another, she affixed a rotating prism to the camera lens. By using these moving devices, she reveals a more comprehensive image of the urban landscape, allowing us to see spaces such as the sky, sections of buildings, or streets that lie beyond the conventionally frontal, fixed view of the camera lens.

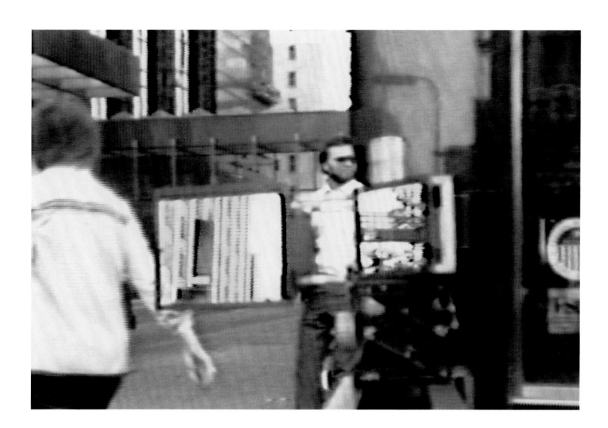

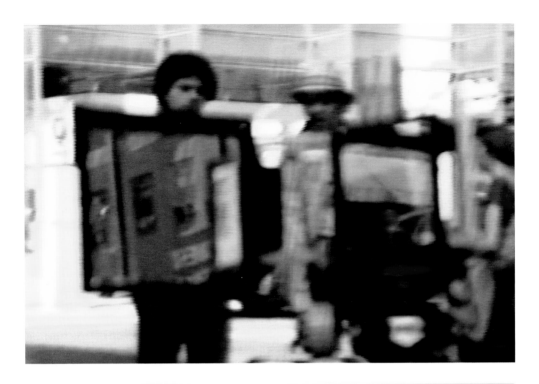

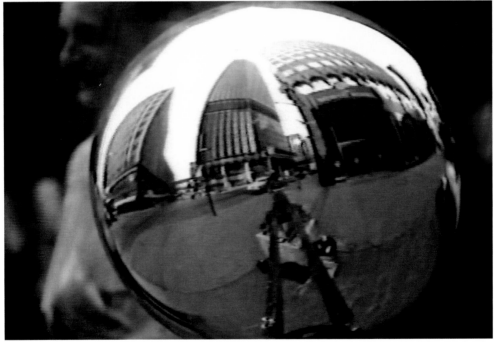

stills from *Urban Episodes*, 1980

Lilith, 1987

In *Lilith*, Steina employs a subject long familiar to the static media of painting and photography: the figure in a landscape. Yet *Lilith* – a name that evokes biblical and mystical references – is anything but traditional. In this video, Steina blurs the boundaries between the natural and electronic landscape and the still and moving image, creating a captivating, psychedelic portrait of the aging painter/poet Doris Cross. Steina used various editing techniques to alter Doris's face, presenting the viewer with an image that exists in a state of perpetual flux: she occupies an indefinable physical and temporal space. Steina's manipulation of sound only enhances the ambiguity of the piece. She distorted Doris's speech to the point of incomprehension using a vocoder, and matched the speed of Doris's garbled voice to the pace of her erratic bodily movements, which at times move in unison with the trees blowing in the wind behind her.

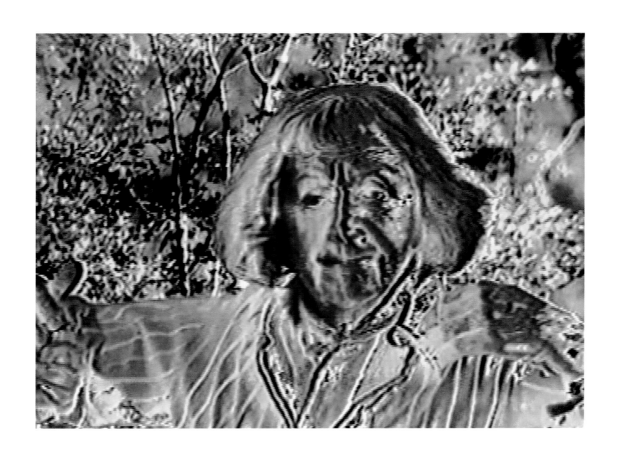

stills from *Lilith*, 1987

Lava & Moss, 1997 (re-mastered in 2000)

Though typically shown in a multi-screen installation format, *Lava & Moss* is an intimate, yet electronically-enhanced view of the natural elements found in the Icelandic landscape. Steina used the camera like a magnifying glass, examining overlooked nooks and crannies among the curious lava formations. Studies in color, texture, volume, density, and pattern emerge from her intense focus. At times, the camera lens seems to sweep perilously close to the ground or appears to be engulfed by ice, which further complicates our sense of space. Steina's editing process involved altering the speeds between still and moving images. Her uneven shifts between images correlate to the unnatural electronic sounds, which are generated intermittently by the movements of her camera. These highly manipu-lated sounds lend the piece a raw and archaic quality, which evokes a sense of an ancient, even primordial past in the present.

stills from *Lava & Moss*, 1997 (re-mastered in 2000)

VocaQuartet, 1990

VocaQuartet is Steina's re-engineered version of two earlier videotapes: *Vocalization One* (1988) and *Voice Windows* (1988). In this work, Steina mixed four channels of video culled from these past projects and arranged them in the form of a quadrant. All three videos are variations on Steina's collaboration with vocalist Joan La Barbara, and reflect her ongoing experimentation with sound/image manipulation. As she did with her violin in *Violin Power*, Steina essentially transformed La Barbara's voice into an image-generating tool by "rigging" it to a variety of electronic devices. When La Barbara sang into the microphone, it triggered effects in a machine that produced images of Santa Fe's urban and rural landscapes to appear in various forms on the screen. Steina demonstrates the imaging process in one of the opening segments of the work. A series of horizontal lines, which look like a music staff, overlay a black background. As La Barbara sang into the microphone, her voice activated the bars, which expand, contract, and morph into different shapes depending on how she used her voice.

stills from *VocaQuartet*, 1990

Trevor, 1999-2000

Trevor is emblematic of the spontaneity, playfulness, and experimentation that runs throughout Steina's work. She approaches many of her projects from a "what if?" perspective, and *Trevor* is no exception. While attending a lecture by avant-garde musician, Trevor Wishart, in Amsterdam, Steina recorded the artist's impromptu vocalizations. Using the Image/ine software that she helped design with Tom Demeyer at the STEIM in Amsterdam, Steina captured the sound of Trevor's frenetic vocal antics and allowed it to determine the speed and the visual effects that occur. The sound splits, folds, and generates displacement in the image, creating the effect which Steina aptly describes as "Trevor's face sliding off his skull."

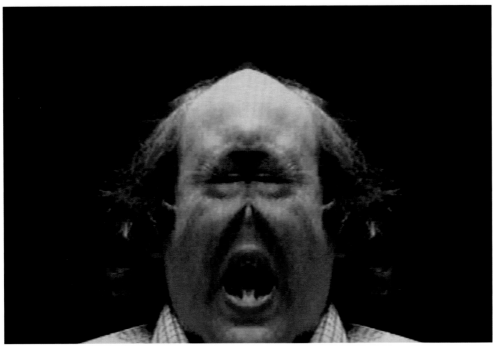

stills from *Trevor*, 1999-2000

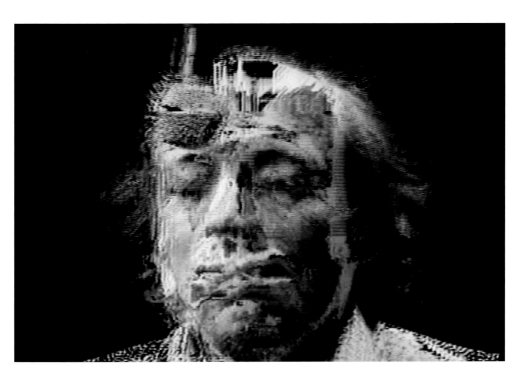

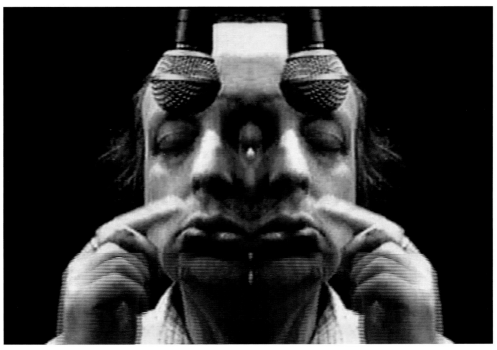

Pyrospheres, 2002

Pyrospheres is an intense, elegant portrait of fire. This single-channel video is made up of footage from Steina's collaboration with metalsmith Tom Joyce. Steina uses gorgeous details of flashing sparks, smoldering embers, and swirls of smoke, "wrapping" the imagery into an endlessly rotating spherical form. Despite the continual motion of the sphere, Steina draws our attention to the array of shapes, colors, and textures that are embedded within the imagery. The electronically-enhanced ambient sound of the flame emphasizes the seemingly primal and ethereal quality of the work.

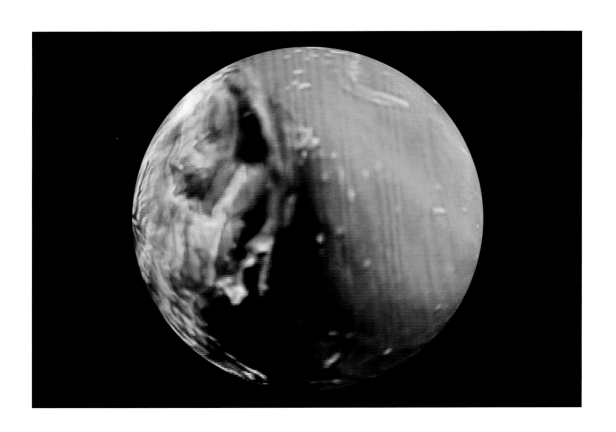

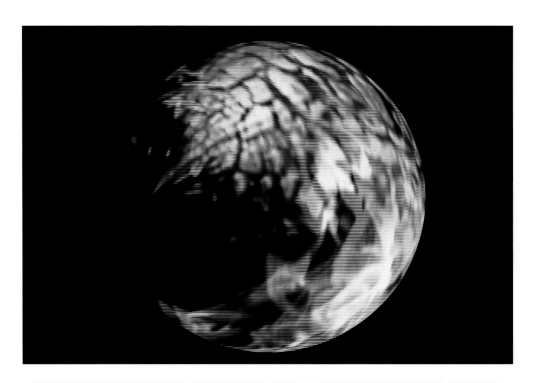

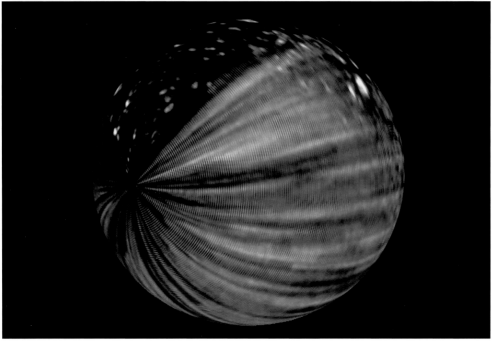

stills from *Pyrospheres*, 2002

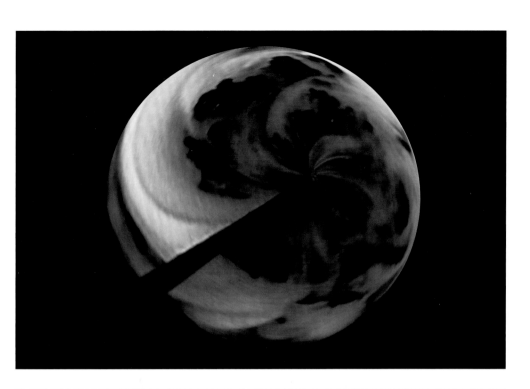

Plates: Installations

Allvision, 1976

Allvision is one of Steina's first electro/opto/mechanical environments. This kinetic sculpture is the centerpiece of *Machine Vision*—a project comprised of videotapes and home-made machine installations that use optical devices and mechanized camera movements to challenge modes of human perception. Steina's means of creating a sense of spatial disorientation are simple yet effective. *Allvision* consists of a mirrored sphere, two cameras, television monitors, a turntable, and a crossbar—equipment that becomes standard fare for many of her ensuing projects. She positions a mirrored sphere between two cameras that are mounted on either end of a long crossbar, which is set atop a motorized turntable. As the cameras orbit the sphere, the nearby monitors display what the camera sees. Although *Allvision* allows us to see the space in its entirety, we experience a kind of spatial no-man's land. (New Media scholar Gene Youngblood has described how *Allvision* embodies what author Jorge Luis Borges calls an *Aleph*—a point in space that contains all other points in space.) Steina does not attempt to resolve this ambiguity. Rather, she situates viewers in an undefined area that lies somewhere between physical and electronic space, causing people to become both the objects of the machine's vision and observers of its actions.

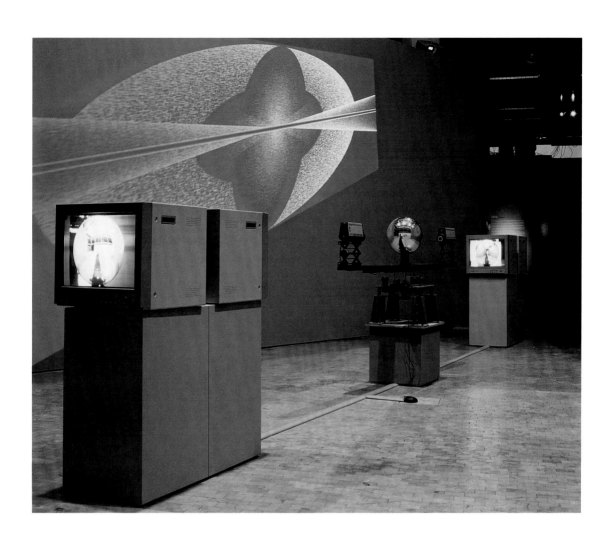

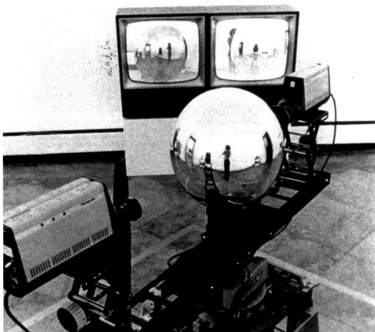

Installation views of *Allvision*

left: Photos by Kevin Noble, courtesy of the artist

pg. 93 & right: Installation views from *MindFrames. Media Study at Buffalo 1973–1990*. ZKM | Center for Art and Media Karlsruhe, photos: Barbara von Woellwarth

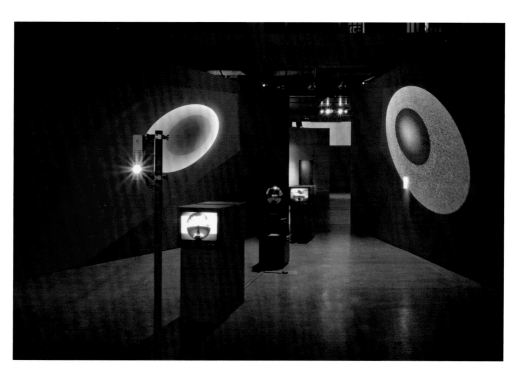

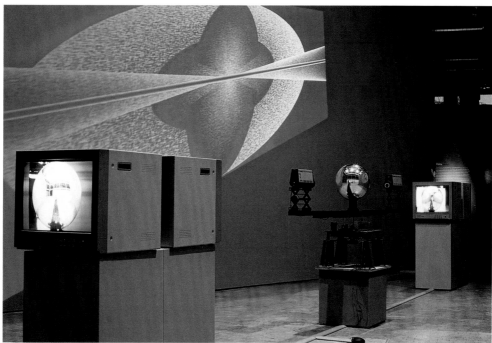

Violin Power, 1978

Violin Power is a study of the relationship between music and the electronic image, and it is emblematic of Steina's playful and singular approach to music, art, and technology. As with some of her other videotapes, this first version of *Violin Power* is a compilation of short, experimental tapes that span almost a decade. The opening segment shows a young Steina playing classical music on the violin. The section that follows presents a more mature artist performing in front of the camera, this time showcasing her lip-synching talents, as she mouths the words to the Beatles song "Let It Be." The remaining portions of *Violin Power* convey a decidedly more serious tone as Steina appears before the camera as both a performer and composer, revealing the power of the violin as an image-generating tool. As she draws her bow across the strings of her electronically-wired violin, the sounds produced by the violin affect the image: new patterns and sinewy lines interrupt the raster lines of the monitor, distorting the picture. Steina used image-altering devices such as switchers and time-delays that create the haunting, ethereal images that reflect a performative self-portrait of an artist whose early experiments with technology anticipated the computer-designed performance software that would emerge twenty years later.

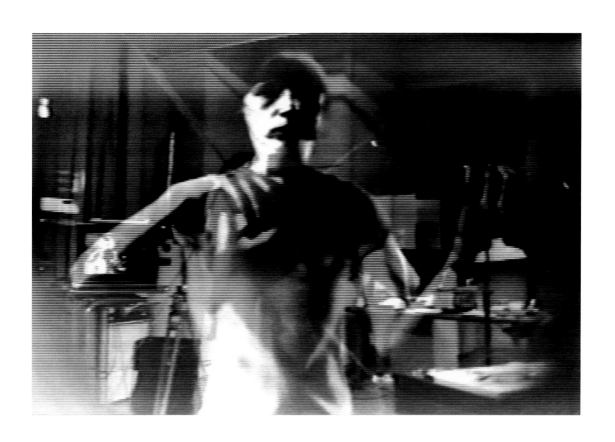

stills from *Violin Power*, 1978

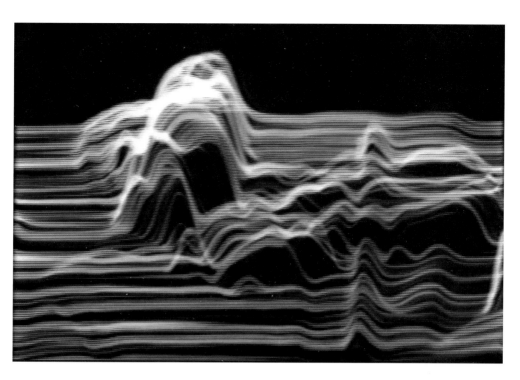

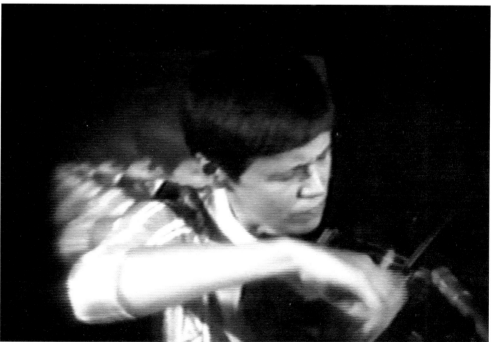

The West, 1983

Sound by Woody Vasulka

Although elements of nature appear intermittently in Steina's videotapes from the 1970s, after she and Woody decamped for Santa Fe in 1980 the landscape itself quickly became a prominent leitmotif in her work. *The West* is a two-channel, multi-monitor installation accompanied by Woody Vasulka's enigmatic soundtrack that uses modern technology to capture the beauty and grandeur of the Southwest. Steina takes viewers on a long journey through this vast, seemingly uninhabited land. Along the way, she brings the ancient past into the present by combining images of the cliff dwellings of the Anasazi Indians with footage of gleaming rotating dishes of the Very Large Array (VLA) radio telescopes that populate the desert. Her electronic manipulations only emphasize the brilliant light, rich colors, textures, and shapes that characterize the desert landscape. In *The West,* Steina continues to draw on the contrasts that exist between the electronic, or artificial, and the natural environment. She concedes that the video medium, despite its adaptability and technical engineering, is limited in its ability to serve as a representational tool. Simply put, the camera can only capture a fragment of a larger image. Steina remarks, "There is no way that you could take this overwhelming beauty and put it into a little box successfully."

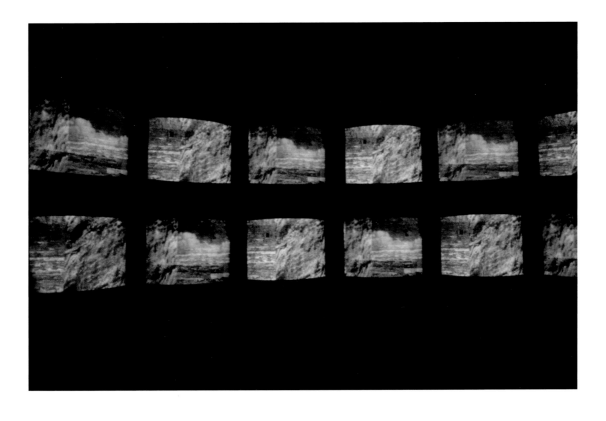

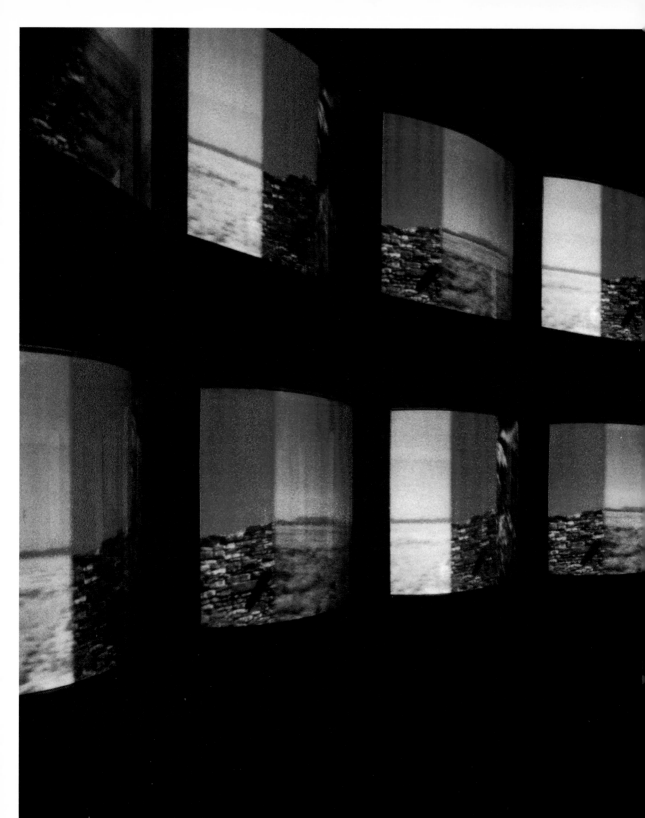

Installation views of *The West,* 1983 at the San Francisco Museum of Modern Art, 1996. photos: Ben Blackwell. Courtesy of the artist.

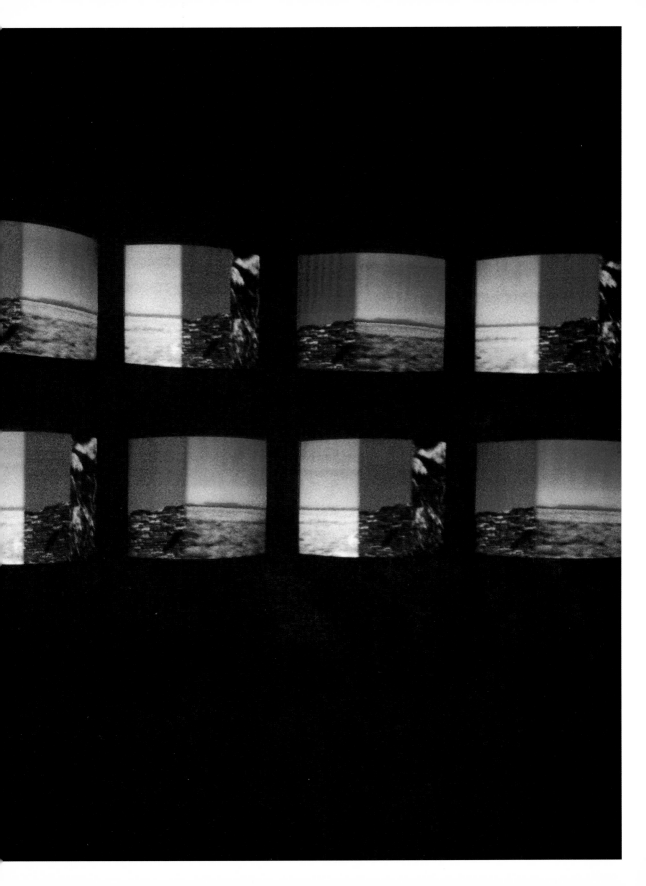

Tokyo Four, 1991

In 1988, Steina received a U.S./Japan Friendship Committee grant to travel and work in Japan. Although frequently an interpreter of the patterns and rhythms that define our natural world, Steina used her powers of observation to record the rituals that govern peoples' social behavior in Japan. *Tokyo Four* is a four-screen, multi-channel audio installation comprised of two independent works, *In the Land of Elevator Girls* (1989) and *A So Desu Ka* (1994), in addition to other recorded footage. As New Media scholar Gene Youngblood notes, "*Tokyo Four* is the audio-visual equivalent of a string quartet, and Steina's organization of imagery is based upon compositional strategies such as duration, interval, repetition, and rhythm that reflect her musical mindset." We see images of Shinto priests tending Zen gardens, train conductors directing traffic with simple hand gestures, Japanese elevator girls hosting people in department stores, produce at a local supermarket, and performances by an avant-garde dance troupe. Steina manipulated the images, controlling them through technical means such as switching, flipping, reversing, and wiping with frequencies that echo people's ritualistic gestures and movements. In effect, *Tokyo Four* is a travelogue through Japanese culture. The electronically-sliding doors, for example, move viewers between cultures, spaces, and places allowing people to briefly experience worlds previously unknown.

Installation view of *Tokyo Four*, 1991

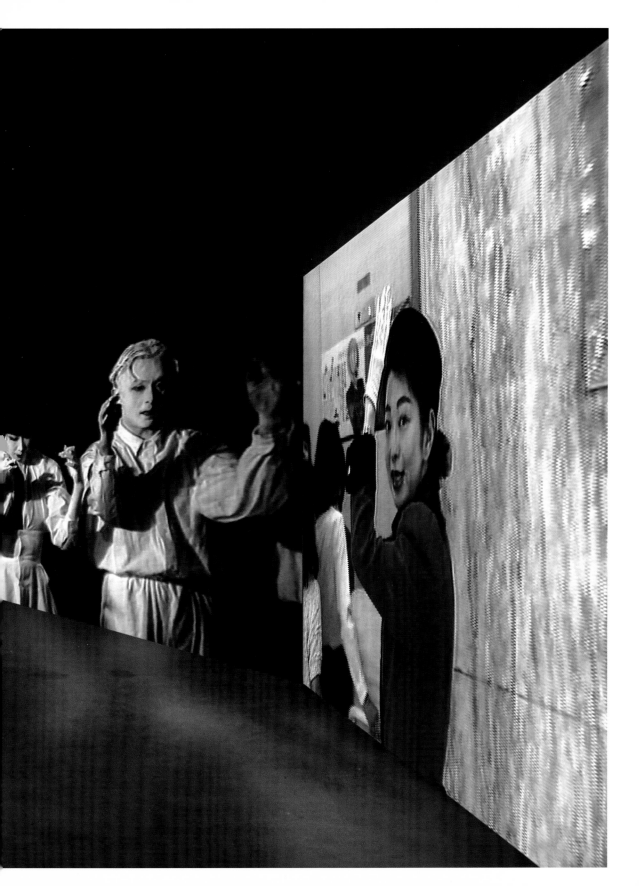

Borealis, 1993

Water has often appeared in Steina's videos and installations, yet no other depiction of it has matched the visceral intensity and spectral beauty of *Borealis.* The title, meaning "northern," takes its name from the Aurora Borealis, or Northern Lights, Mother Nature's inimitable light show, which is visible in northern locales such as Steina's native Iceland. *Borealis* is a two-channel video installation with multiple channels of sound. It consists of four large-scale, free-standing, translucent screens in a dark room. Steina outfits the two video projectors with dichroic mirrors – devices layered with a special optical film on the surface – that split the projected images onto two screens. Steina's inverted images, close-ups of Iceland's rivers and churning seas, are accompanied by the ambient sounds of nature. The water moves violently, surging and charging at a frenetic pace as it courses in unusual directions. It flows vertically, as well as forwards and backwards, creating dizzying, disorienting effects. Using projected video, Steina not only reconfigures physical space, but also creates a new hybrid environment capable of expressing the sheer magnitude of nature through technological means.

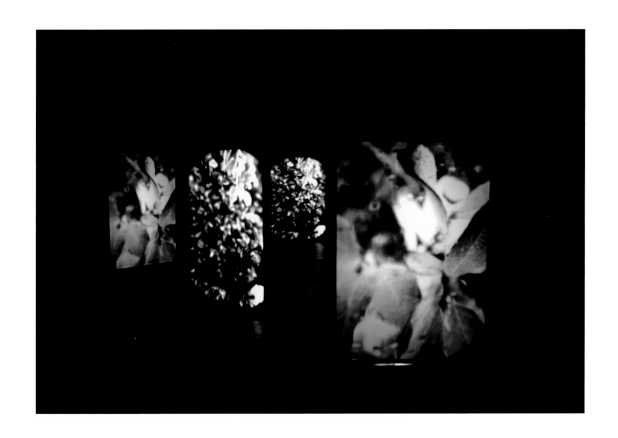

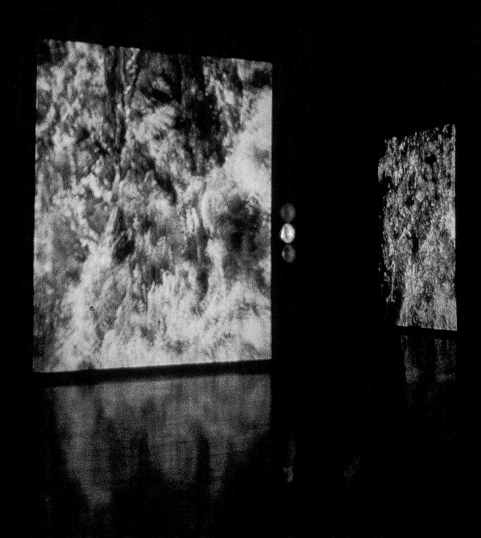

above & pg. 109: Installation views of *Borealis*, 1993 at the San Francisco Museum of Modern Art. 1996, photos: Ben Blackwell, Courtesy of the artist.

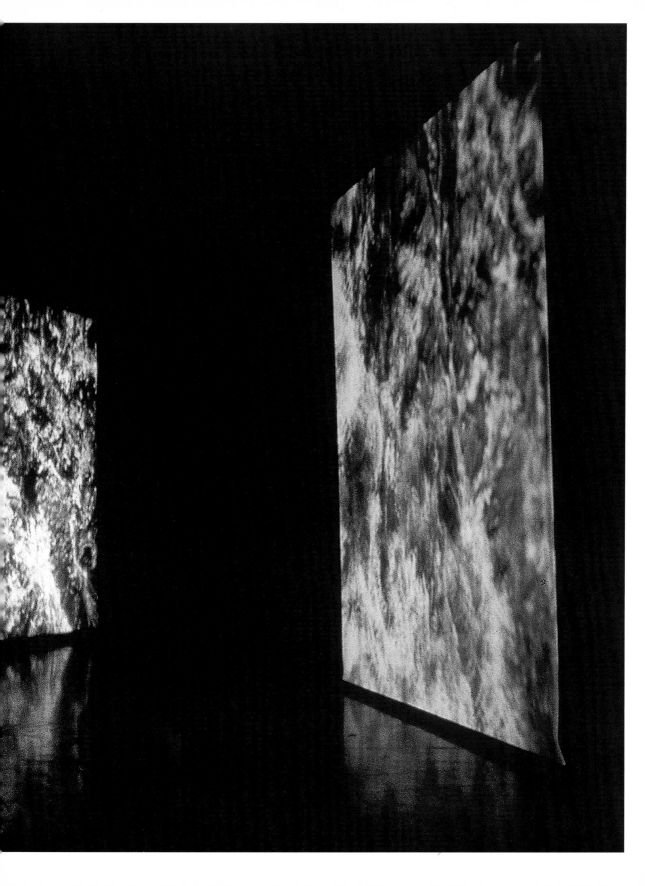

Pyroglyphs, 1995

Pyroglyphs is the stunning result of Steina's collaboration with the sculptor and metalsmith, Tom Joyce. Exhibited as a three-channel video installation with multiple channels of sound, *Pyroglylphs* is a hypnotic display of one of Earth's most basic elements – fire. The recorded imagery derives from Joyce's foundry in Santa Fe, New Mexico. Steina shot close-ups of Joyce hammering, forging, and heating different materials. Her camera lingered on the sparks, flames, and smoke created by Joyce's blacksmithing activities. Joyce experiments with other materials too: we see a vise crushing timber and the smoldering embers from stacks of burning wood and paper. Using a variety of electronic controls, Steina slowed the speed of these all-consuming flames to an achingly slow crawl, revealing the rich hues and various textures that were previously invisible to the human eye. The sound that accompanies *Pyroglyphs* is as compelling as the visual images that fill its multiple screens. Steina processed the sounds of blowtorches, flames, and hammering metal through a digital device that allowed her to "move" the sounds into unlikely rhythms. A collection of sonic patterns emerge that evoke an archaic, even primeval past.

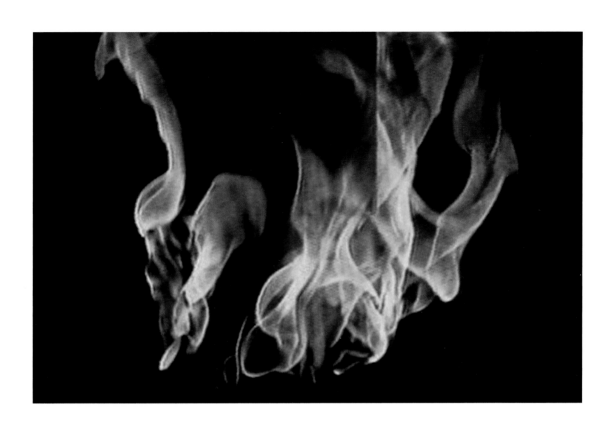

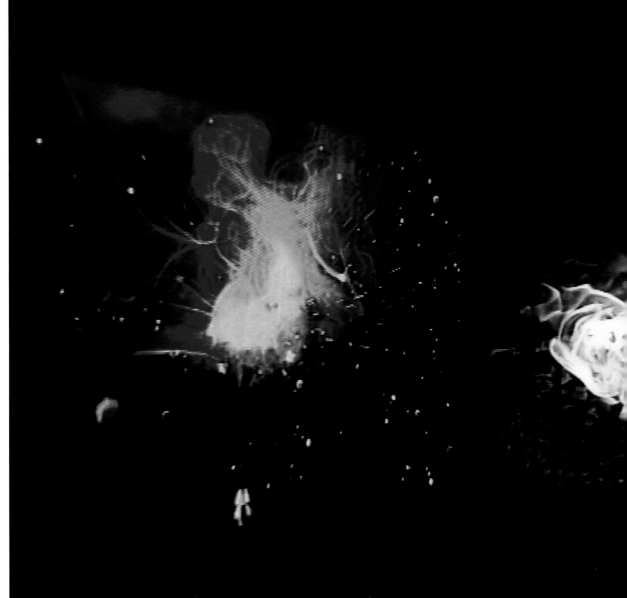

Installation view of *Pyroglyphs*. 1995

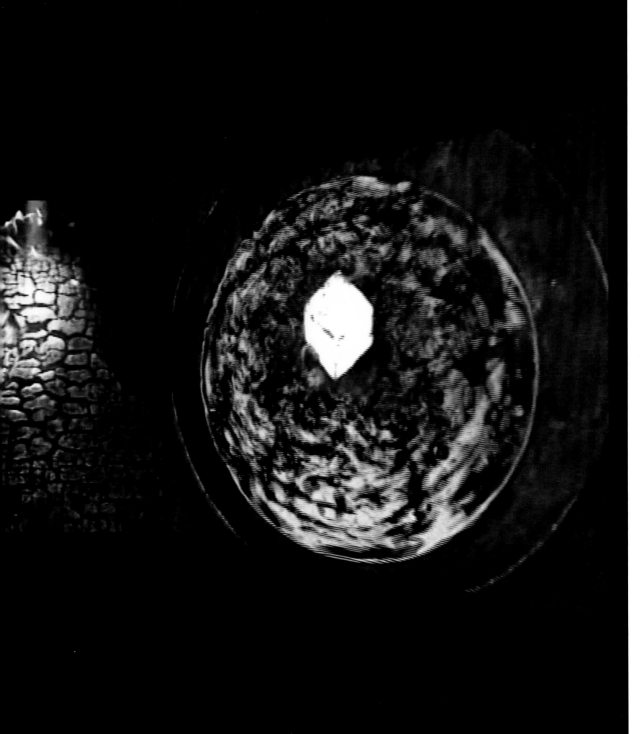

Mynd, 2000

As with her other multi-channel, projected environments, *Mynd* is a spectacular
six-channel video installation that transports the veiwer to another time and place,
immersing spectators in the overwhelming beauty of nature. The source material for *Mynd*
is previously recorded video of the Icelandic landscape. Images of water, ice floes, and
grazing horses, as well as fragments of craggy coastlines and threatening skies, are
accompanied by muted, ambient sounds of nature. Steina created the processed imagery
in *Mynd* using the "time-warp" and "slit-scan" modes of the interactive, performance com-
puter software Image/ine. These modes can "read" the image frame by frame and line by
line, from any direction, which allowed her to use the same image repeatedly but with varying
effects – she reverses, freezes, inverts, twists, stretches, or compresses the image however
she chooses. In *Mynd*, Steina combined these two types of processing techniques. What
results is a hybrid environment composed of parallel moving and frozen images that scroll
continuously around the room, wherein viewers experience a visual paradox between stasis
and movement.

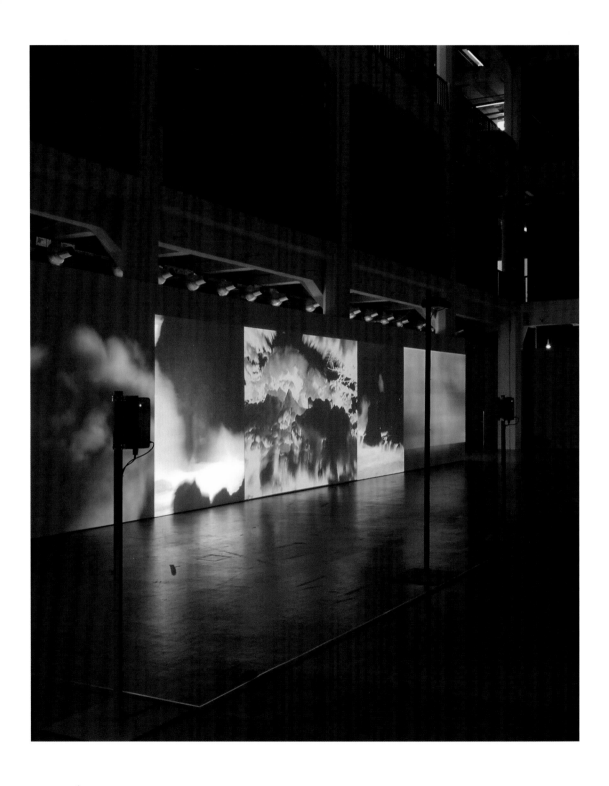

Installation views of *Mynd*, 2000, *MindFrames. Media Study at Buffalo 1973–1990*. ZKM | Center for Art and Media Karlsruhe, photos: Barbara von Woellwarth

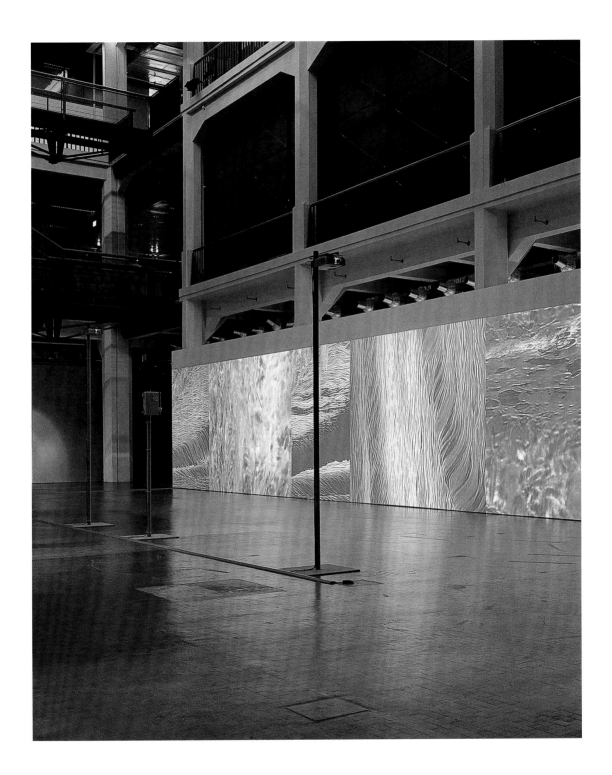

exhibition checklist

Single-Channel

Decay I, from *Studies Series*, 1970
½ " Open Reel video
Color, sound; 1 min. 50 secs.

Decay II, from *Studies Series*, 1970
½ " Open Reel video
Color, sound; 1 min. 45 secs.

Descends, from *Studies Series*, 1970
½ " Open Reel video
B/W, sound; 4 mins. 18 secs.

Tissues, from *Studies Series*, 1970
½ " Open Reel video
B/W, sound; 1 min. 29 secs.

Let It Be, 1970
½ " Open Reel video
B/W, sound; 4 mins. 1 sec.

Participation, 1970-71
½ " Open Reel video
B/W, sound; 63 mins.
In close collaboration with Woody Vasulka

Distant Activities, 1972
½ " Open Reel video
Color, sound; 4 mins. 45 secs.

Land of Timoteus, 1975
½ " Open Reel video
B/W, sound; 6 mins. 45 secs.

Flux, 1977
¾ " U-matic video
B/W, sound; 8 mins. 10 secs.

Orbital Obsessions, 1977 (re-mastered 1988)
½ " Open Reel video
B/W, sound; 24 mins. 10 secs.

Violin Power, 1978
½ " Open Reel video
B/W, sound; 9 mins. 10 secs.

Bad, 1979
¾ " U-matic video
Color, sound; 2 mins. 4 secs.

Cantaloup, 1980
¾ " U-matic video
Color, sound; 22 mins. 50 secs.
In collaboration with Jeffrey Schier and Woody Vasulka

Selected Treecuts, 1980
¾ " U-matic video
Color, sound; 6 mins. 40 secs.

Urban Episodes, 1980
¾ " U-matic video
Color, sound; 9 mins.
Additional engineering by Woody Vasulka and Josef Krames

Summer Salt, 1982
¾ " U-matic video
Color, sound; 17 mins. 50 secs.

Aria, 1987
¾ " U-matic video
Color, sound; 3 mins. 10 secs., Protagonist: Doris Cross

Lilith, 1987
¾ " U-matic video
Color, sound; 9 mins. 10 secs., Protagonist: Doris Cross

In the Land of Elevator Girls, 1989
SVHS video
Color, sound; 4 mins. 14 secs.
In close collaboration with Woody Vasulka

VocaQuartet, 1990
¾ " U-matic video
Color, sound; 11 mins. 35 secs.
Composer and performer: Joan La Barbara

A So Desu Ka, 1994
SVHS video
Color, sound; 9 mins. 30 secs.

Lava & Moss, 1997 (re-mastered 2000)
Digital video
Color, sound; 13 mins.

Trevor, 1999 - 2000
Digital video
Color, sound; 11 mins.
Composer and performer: Trevor Wishart

Pyrospheres, 2002
Video Hi-8
Color, sound; 5 mins. 57 secs.

Rome Performance, 2004 from *Violin Power the Performance*, 1991 – present
Interactive performance, digital video
Color, sound; 14 mins. 40 secs. loop

Installations

Allvision, 1976
Closed-circuit electro/opto/mechanical environment; 2 video cameras,
2 video monitors, mirrored sphere, turntable assembly
B/W, silent
Engineered by Woody Vasulka

The West, 1983
Two video/four audio channel matrix
Color, sound; 30 min. cycle
Audio by Woody Vasulka

Tokyo Four, 1991
Four-channel video/audio installation
Color, sound; 19 mins. 45 secs. loop
Initial editing and consultation: Hope Atterbury

Borealis, 1993
Two video/four audio channel projected environment
Color, sound; 10 mins. 30 secs. loop

Pyroglyphs, 1995
Three-channel video/audio installation
Color, sound; 20 mins. loop
In close collaboration with Tom Joyce

Mynd, 2000
Six-channel video/audio installation
Color, sound; 16 mins. 39 secs. loop

All works in the exhibition are courtesy of the artist and shown
in digital format regardless of origination medium.

acknowledgements

Steina: 1970-2000 is made possible, in part, by generous support from the Board of Directors of SITE Santa Fe as well as the following institutions and individuals:

The Andy Warhol Foundation for the Visual Arts

The Brown Foundation, Inc., of Houston

The Burnett Foundation

New Mexico Arts, a division of the Department of Cultural Affairs, and the National Endowment for the Arts

Thaw Charitable Trust

The City of Santa Fe Arts Commission and the 1% Lodgers' Tax

WD Foundation

This catalogue has been published on the occasion of the exhibition:

Steina: 1970-2000

February 16 – May 11, 2008

ISBN: 978-0-9764492-7-0

Library of Congress Control Number: 2007943192

SITE Santa Fe

1606 Paseo de Peralta, Santa Fe, New Mexico 87501

Tel: 505.989.1199 Fax: 505.989.1188

www.sitesantafe.org

Design: Skolkin+Chickey, Santa Fe

Managing Editor: Joanne Lefrak, Editor: Katia Zavistovski

Photos, pgs 8, 106-107, 114-115, digitally created by Brian Bixby

Printed and bound by SNP Leefung, China

frontispiece: installation view of *The West,* 1983 at the San Francisco Museum of Modern Art, 1996. photo: Ben Blackwell.

page 4: detail of still from *Trevor,* 1999–2000

pages 6-7: installation view of *Borealis,* 1993 at the San Francisco Museum of Modern Art, 1996. photo: Ben Blackwell.